IDENTITY
IN & BEYOND THE BINARY

IDEN

IN & BEYON

TITY

THE BINARY

DAVE NAZ

BARNACLE / RARE·BIRD
LOS ANGELES, CALIF.

Also by Dave Naz

Genderqueer
Butt Babes
A.S.L.
L.A. Bondage
Fresh
Legs
Panties
Lust Circus

Dedicated to the people who shared their lives with me through photo and conversation. I learned from each of your stories and couldn't have made this book without your contribution and belief in the project.
—Dave Naz, 2017

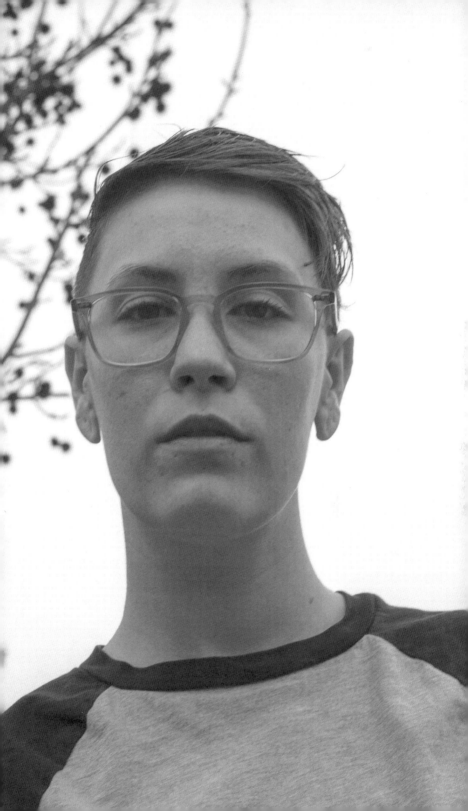

Life of Firsts

Riley Kilo

I NEVER EXPECTED THE newness of it all. I was in my late teens, an absolute nervous wreck driving to Berkeley for a trans event during Pride. I had been out "as a girl" a few times, but only at Halloween or under cover of night. I was still horribly self-concious about my entire existence, voice, clothes, smell, everything. I had shoes that didn't fit, a skirt that didn't match, and hair that wouldn't behave, but I wasn't going to miss the opportunity to be around other folks going through the same things I had. I could count the transpeople I'd met on one hand. My exposure to the community at that point was mostly media portrayals of transwomen, who seemed to always be troubled, evil, or punch lines. It gave me a pretty bleak outlook: do struggle and negativity come with transition? Could I handle the social/personal issues that seem to be synonymous with transition? Would anyone ever accept, tolerate, or love me if I came out? These questions demanded answers, and I had reached the extant that introspection and crying myself to sleep could tell me. I needed to talk to other transpeople to figure this whole Riley thing out.

I sat in the parking lot for a bit to get myself more confident, but I was chain-smoking and progressively

getting more and more nervous. I debated going home to do everything I could to turn off the feelings that lead me here, I didn't think I could handle the realities I'd face if I went further down the gender identity rabbit hole. What changed my mind was seeing two smiling, queer women walk by holding hands. Embarrassingly, I immediately tried to read if they were trans or not, but I realized that it didn't matter and I was sitting in a smokey car intensely staring at strangers. At that point in my life, I needed to make a decision about which person I wanted to be, the out and proud queer woman or the awkward voyeur relegated to parked cars and dark rooms. I thought on it for a moment then got out of the car, straightened my skirt, and made my way toward the speech I was attending. Even though I'm fairly short and was wearing flats, I felt like a giant. I feared that as soon as anyone saw me they'd point at me and scream like *Invasion of The Body Snatchers*. I kept on walking, quietly observing the few queer/alternative-looking people along the way, like a birdwatcher who secretly wishes they were a bird. I looked and felt a bit like a lost child, so I started following the crowd to the speech.

The group grew larger and larger as we approached the auditorium, and when I finally stepped inside, something amazing happened. I didn't feel alone. Looking into this three-hundred-strong audience of people, I realized that we were all in this together. There were transpeople, allies, non-binary people, and just curious students all joining together to get a better understanding of ourselves and our shared experiences. I nearly fell over. I had never seen so many trans people in my life. I began to not be ashamed of the feelings

I had, as if they were no longer a curse, but an opportunity to truly explore myself and my identity. It was my first time feeling accepted, and it was the first of many new feelings.

Before I first came to understand myself and began to live authentically, my life was like a book not worth finishing. The little achievements in life: first date, first car, or first base, seemed routine, not a celebration. It felt like accepting an award for someone else. That moment at the convention, started an adventure in my life that is beyond anything I had imagined. Everything felt new after that. I felt like the fog of war had lifted, and the first time I walked around my neighborhood as the authentic me was akin to walking out of a dark theater into the sunlight. I was practically squinting at the newness of it all. I was starting to understand why I had always felt so weird inside.

The firsts continued, some good and some bad. I bought my first bra, was a bridesmaid, had my first girl-girl relationship. There were plenty of wonderful firsts, but it wasn't all sunshine. I was discrimanted against for the first time, cat-called for the first time, felt the gaze of predators for the first time. There have been moments where I've just cried and cried due to the struggles of womanhood, but before I began this journey I never shared any emotions, I bottled them up like I was told a young man should. There have been wonderful highs and devastating lows, but that's life and I'm living it, much happier with the challenges than with the shell, the lie of an existence that I lived before.

It's been nearly ten years since seeing that lecture hall full of like-minded people, and I have seen much greater

crowds since: thousand-strong pride parades and advocacy marches, more positive trans people in the media, a growing awareness toward the needs of the community. There have been many firsts since then for the whole community. I can follow my own evolution alongside society's, where I was once a confused young person looking for answers, the world may feel the same way. Our perception of gender and identity is finally up for discussion, and I expect many landmark moments in my lifetime.

Find each other. I may have seemed like just another face in the crowd that day, but I can assure you my every molecule was electric with wonder and anticipation. You never know if someone is having the most amazing experience, even if it's just their first time being themselves.

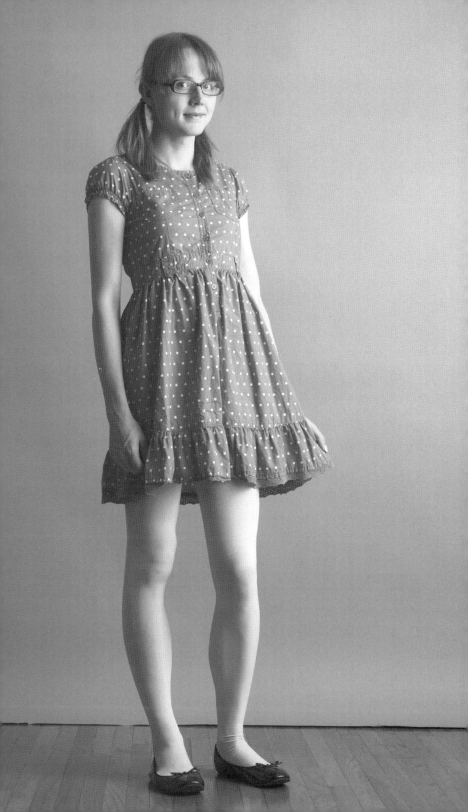

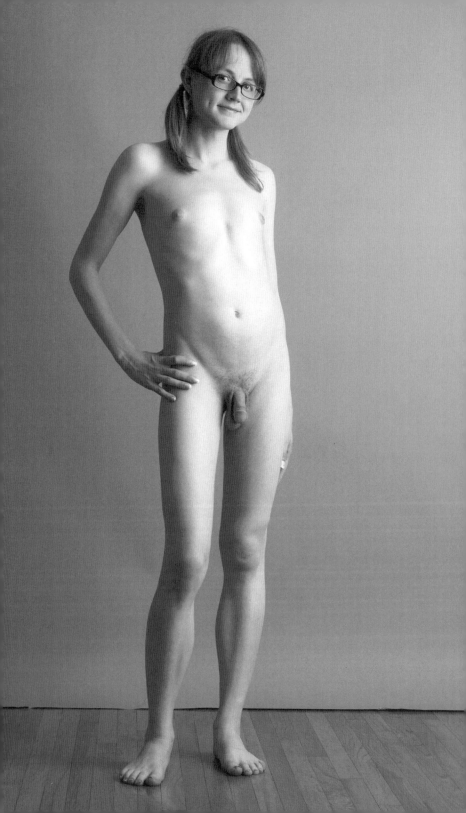

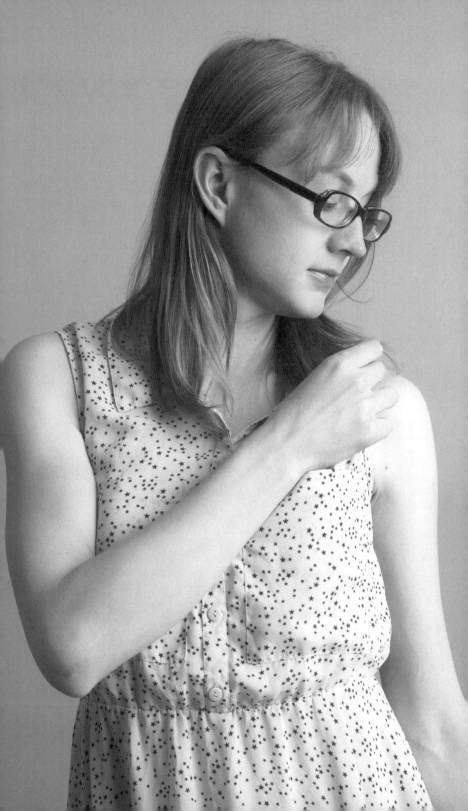

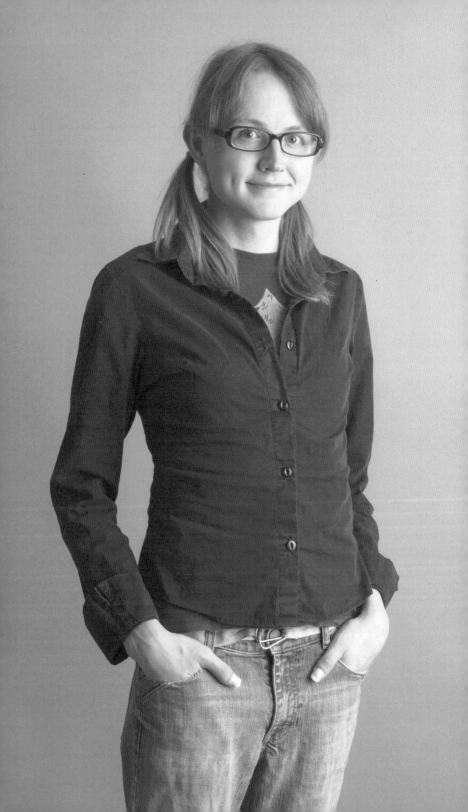

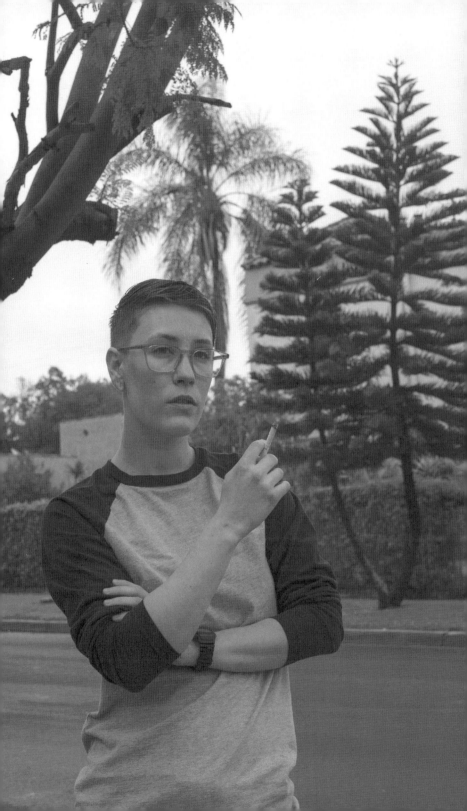

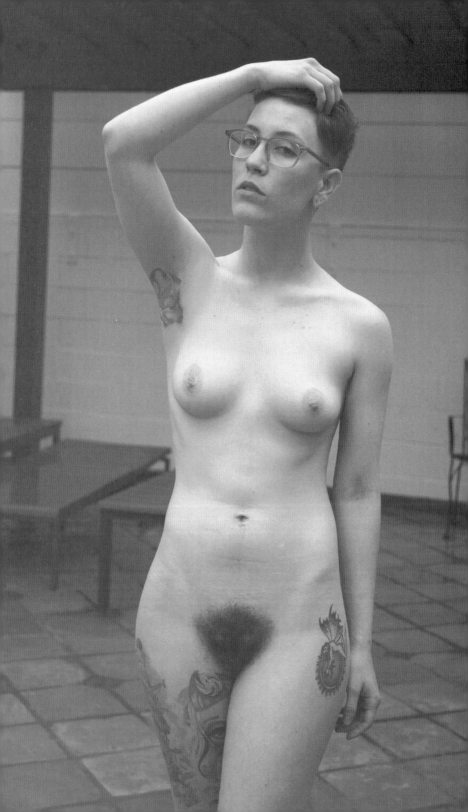

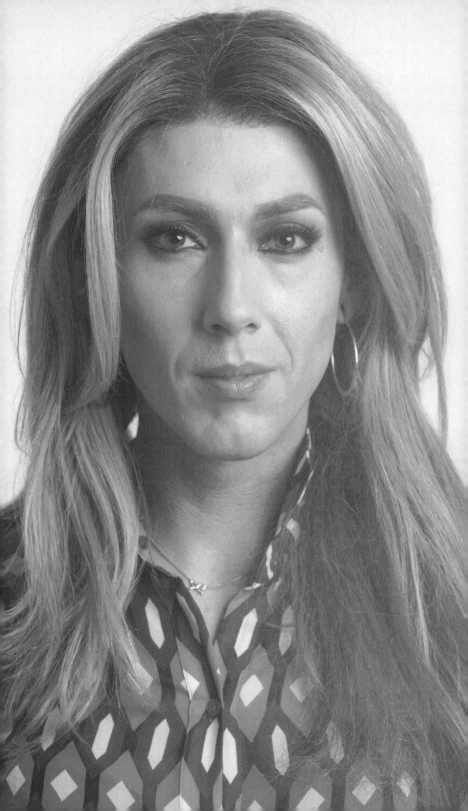

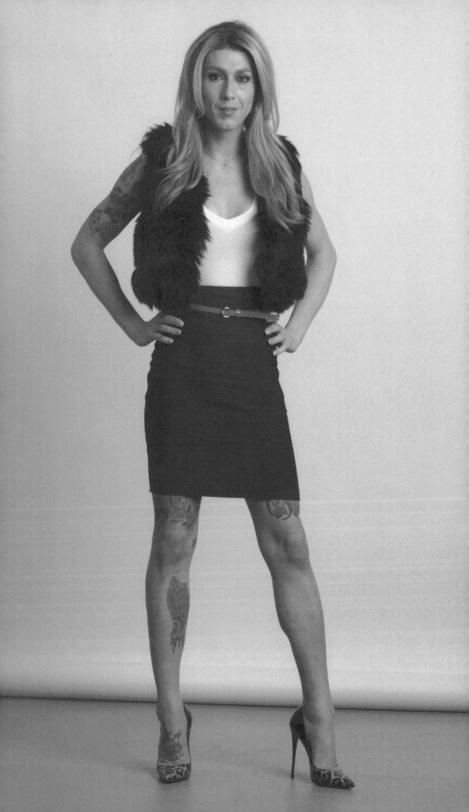

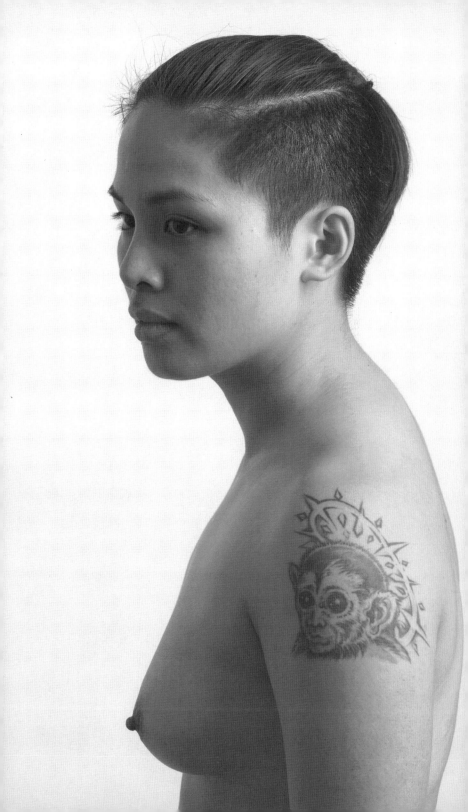

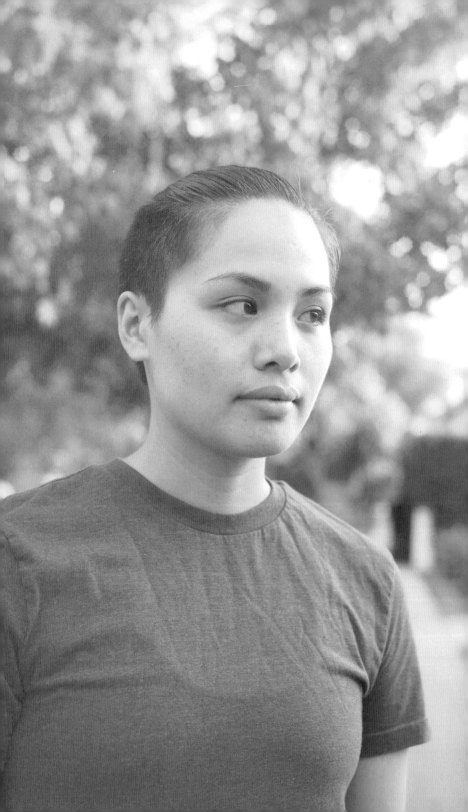

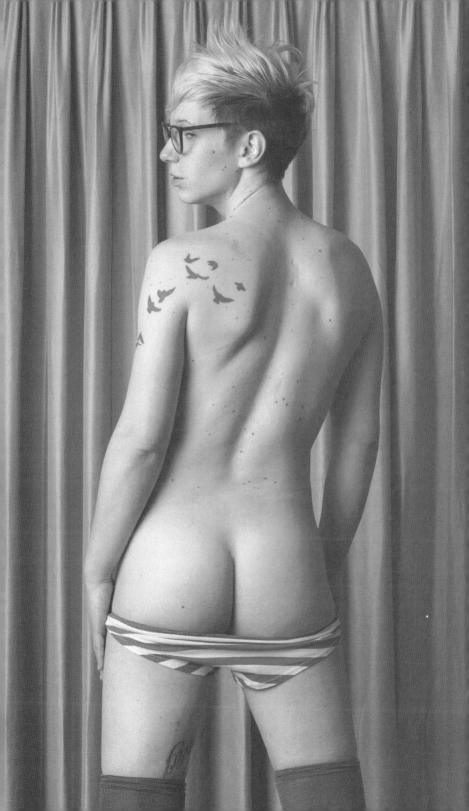

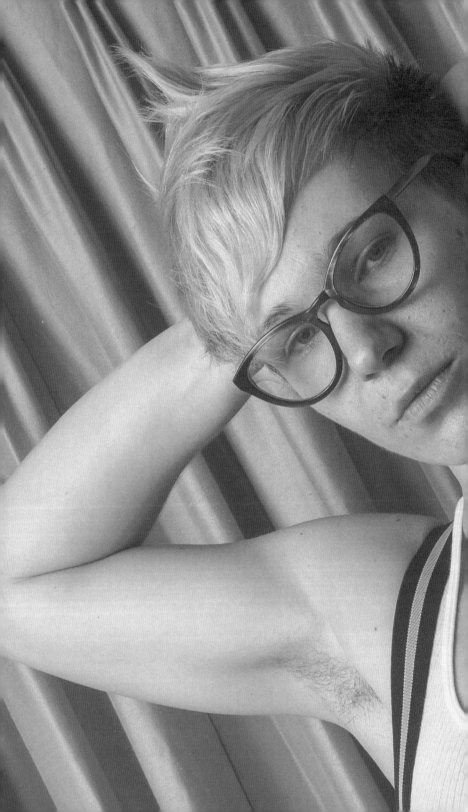

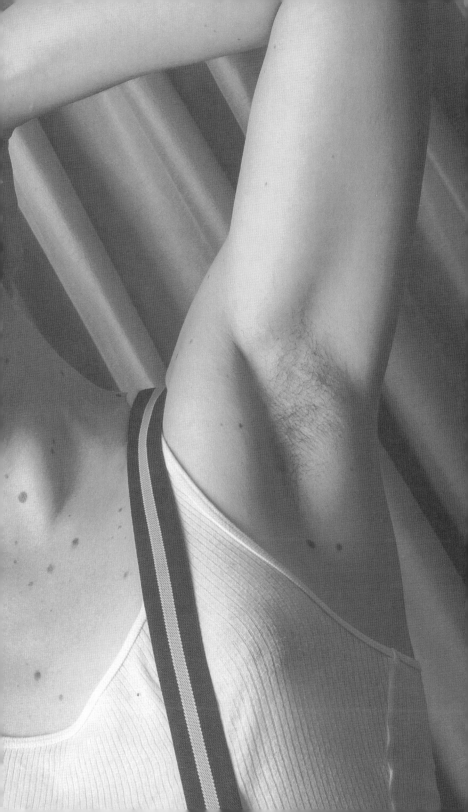

Porno Punk

Chelsea Poe

WHEN I WAS GROWING up, I didn't really expect to ever leave my hometown. I grew up heavily involved in the punk and hardcore scene doing DIY shows and booking my band in cities I had never been to before. As I got older, I felt more and more isolated being a trans person in the Midwest without much access to art that depicted queerness, transness, or anything that came close to what I was feeling. I ended up living on a college campus and being a cam girl to pay the bills and bringing in more punk bands from out of the area for my DIY shows. I ended up hearing that queer porn performer Jiz Lee was speaking at the university where I lived. After seeing queer porn on a big screen, I had a moment where I realized that this was what I was supposed to do. I ended up getting cast in the *Crash Pad Series* later that week and then flew cross-country to do two shoots—one with Dylan Ryan and Courtney Trouble, and another mainstream trans porn shoot. I thought it was going to be a one-time thing that was going to be something I could talk to my friends about. But I found everything I needed and wanted in this art.

From day one, I had the goal of coming into this industry and trying to question it's treatment of trans women. In everything I had seen in my life before, queer porn depicted trans women as some fetishized "other" gender that was neither a man nor a woman, with transphobic language marketing on any site. As I got further into porn, I ended up shooting for more and more of these companies, until these companies realized my politics didn't line up with their business practices. On a red-eye flight, at 3:00 a.m., I decided to start a change.org petition that called for an end to transphobic slurs in the marketing of trans porn. This was the moment that I realized that I was indeed just a Midwestern punk girl thrown into a multimillion-dollar industry that didn't and doesn't really care what I or any other trans women think. The backlash I received from mainstream trans porn was extreme, and effectively blacklisted me from nearly all of the mainstream trans porn industry. I was told time after time that trans porn simply wouldn't sell without the use of slurs. Growing up being in a DIY scene, this struck a chord with me as well as many trans women, directors, and trans allies.

Just a few months after I started the petition, I became the first trans woman to become a God's Girl. I had heard from a lot of people that trans womens' inclusion in nontrans-specific websites would cause mass outrage, which was proven untrue after I and Freya Wynn submitted sets that were treated as any other God's Girl. The way I was treated in the industry, as a whole, changed overnight and I was able to get work with a lot of amazing people who were the reason I got into the industry in the first place. People like Courtney Trouble, Nica

Noelle, Bella Vendetta, and April Flores. The concept that you need to find the right people in this industry is something I find to be true. The idea of needing studios to cast you to get work always felt extremely uncomfortable to me, with them having control over nearly everything involving the project, so I started producing my own films in the most indie punk way possible — staying on couches and taking low-cost buses. I wanted to make a living doing art, and porn is the medium that I felt most connected with.

I believe porn is overlooked in our society as "just porn," while it largely informs and educates the public about sexuality due to the lack of sexual education in American schools. I hear many performers and directors say that "porn shouldn't be sex ed," but it has a huge influence on all of society. I think that, instead of downplaying the role of porn, we, as pornographers, should step up and embrace the influence we have in a positive and authentic way.

I believe porn is a blank space for whoever puts in the effort and explores the medium. The role of women in positions of power in porn is drastically more prevalent than in Hollywood. I don't label all the films I personally produce as trans porn. I think it's important for a trans woman not to have to make pornography about being trans. I believe that one of the best ways to talk about someone being trans in a film is simply not to talk about it. I want trans women to be depicted as full, normal characters in my films, and the easiest way to do that (for me) is to just treat it like I do in my actual sexual life. I rarely have conversations about being trans with my partners before or after sex. My community realizes trans

people exist, so it's really not a big deal to have sex with a trans person. In mainstream trans porn, I feel like a large part of the porn is about how it's taboo to have sex with a trans woman, which is something I want to see done away with. If we continue pushing the narrative of trans women being a fetishized, taboo third gender, the world will continue to treat marginalized trans women with the same disdain that has lead to this becoming one of the most violent years for trans women, and particularly trans women of color in history.

I realize porn is like any form of art—you have people participating in it for a lot of different reasons. You have people who are able to separate their work from their real life, you have people who are looking for a quick buck, it can be used as a rope to pull people from poverty, you have people doing this as a form of art. No matter what, you have a largely powerless work force controlled by the men who run these major companies—performers currently cannot unionize due to the fact that we aren't legally employees. Unlike other workers, we cannot actively make complaints or demands without the risk of being blacklisted. The issues that run through the porn industry aren't unique to sex work. Until performers are given the legal right to unionize, you will continue to see problematic depictions of marginalized groups such as trans women.

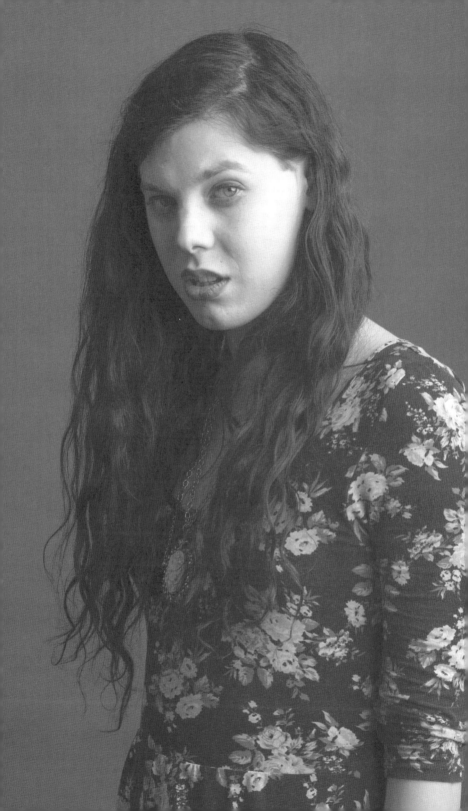

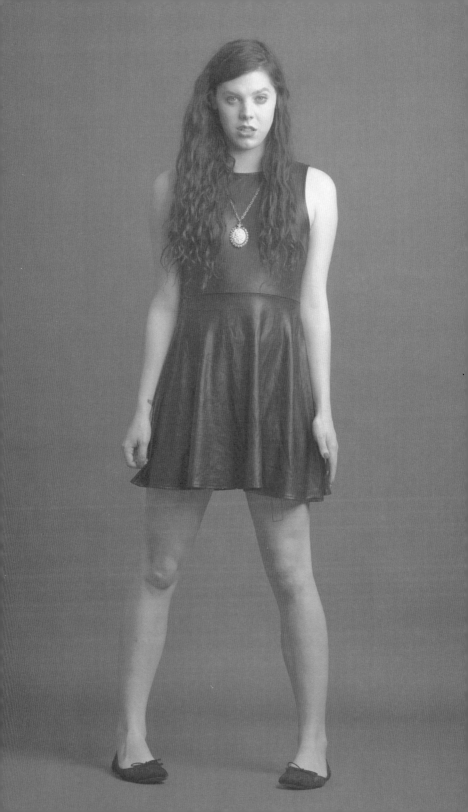

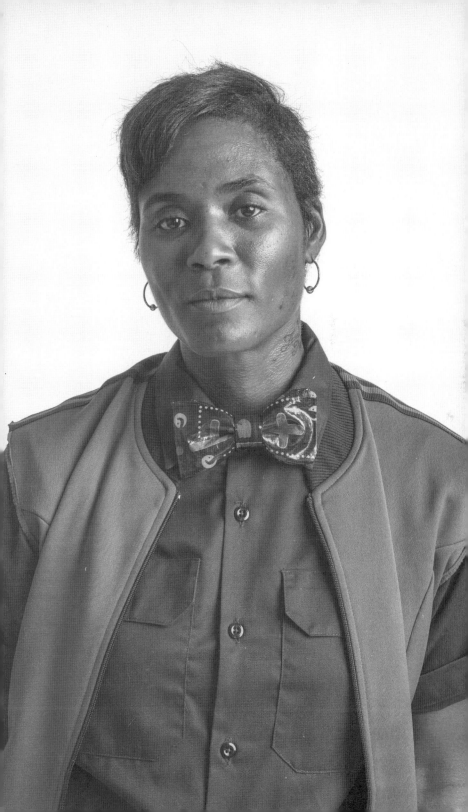

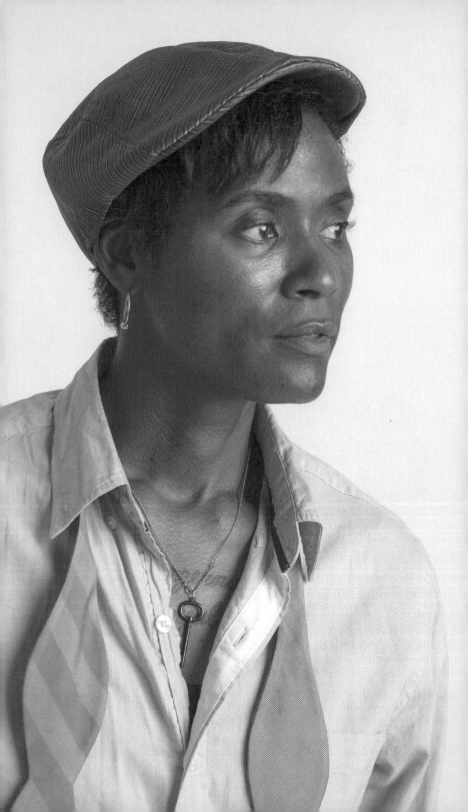

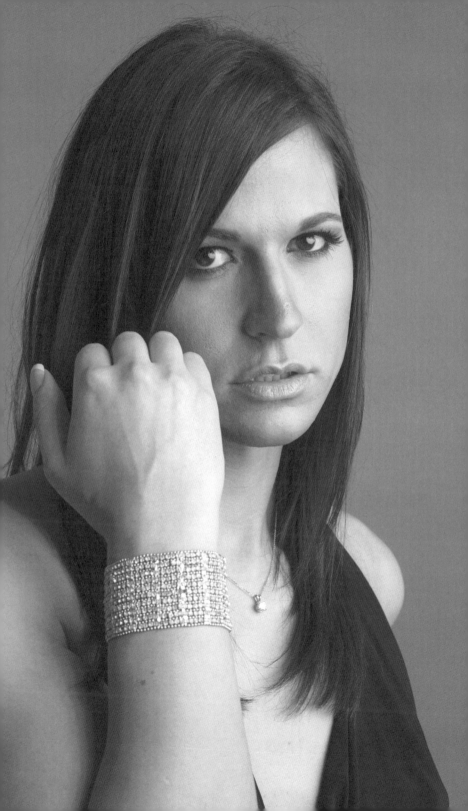

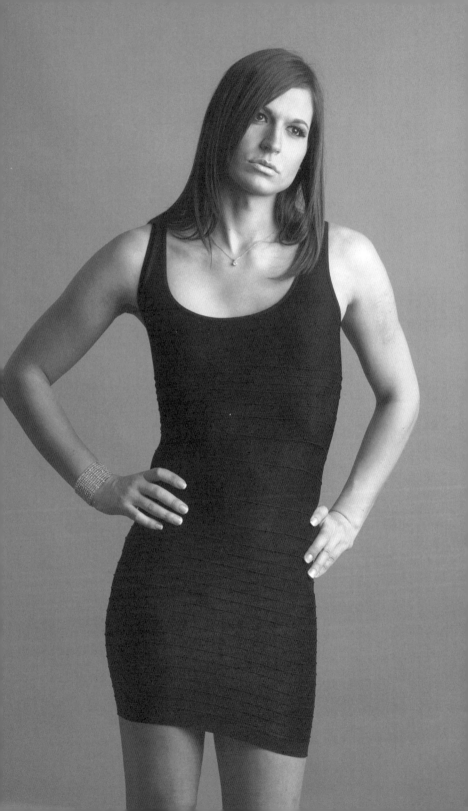

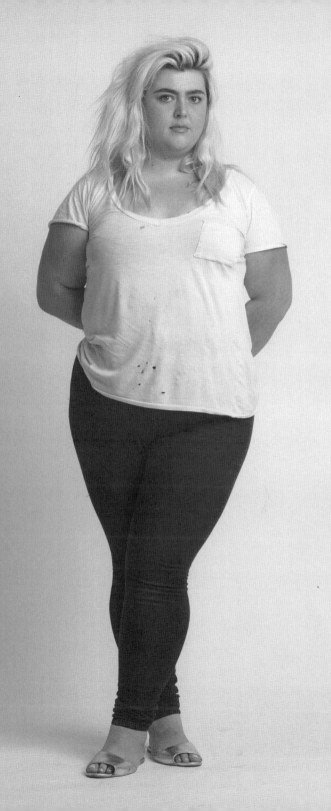

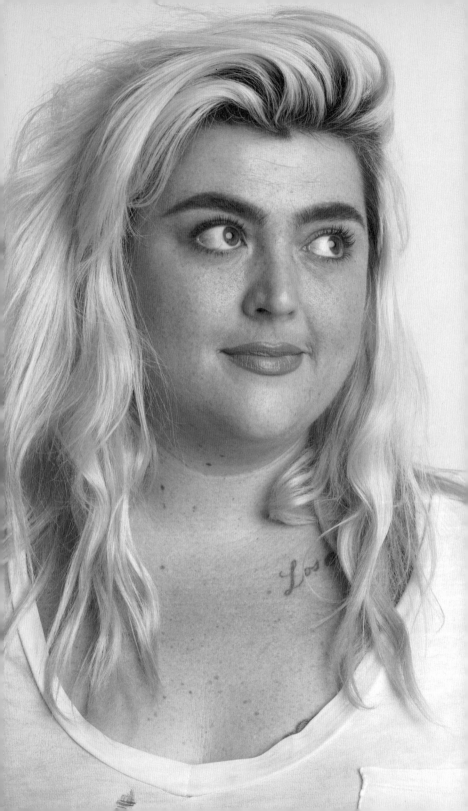

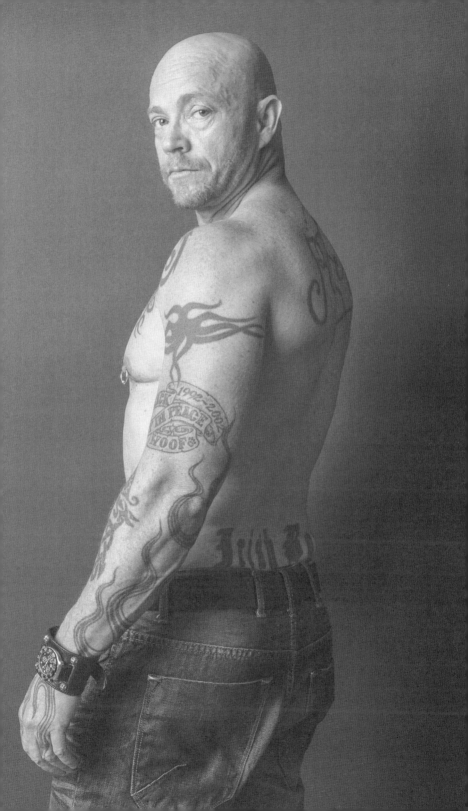

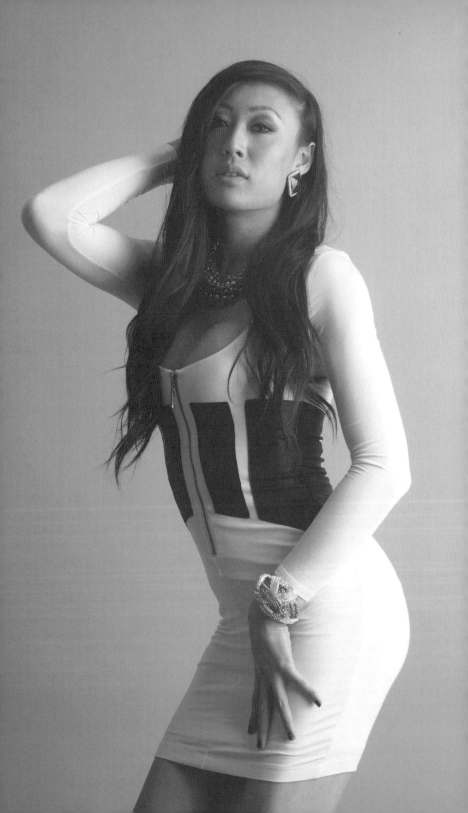

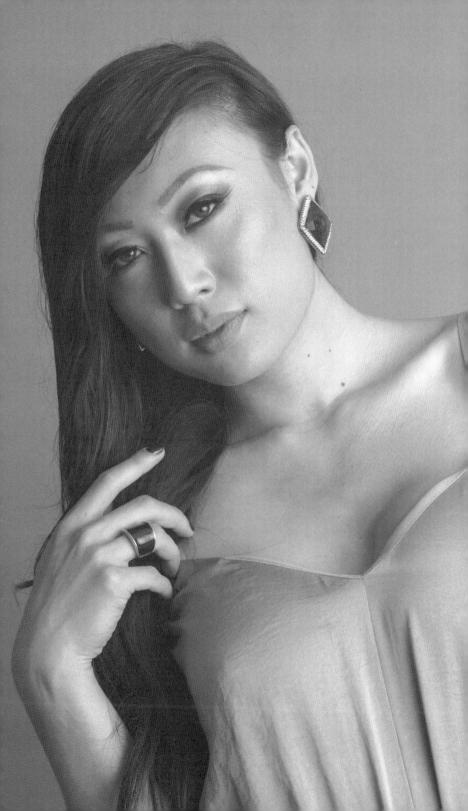

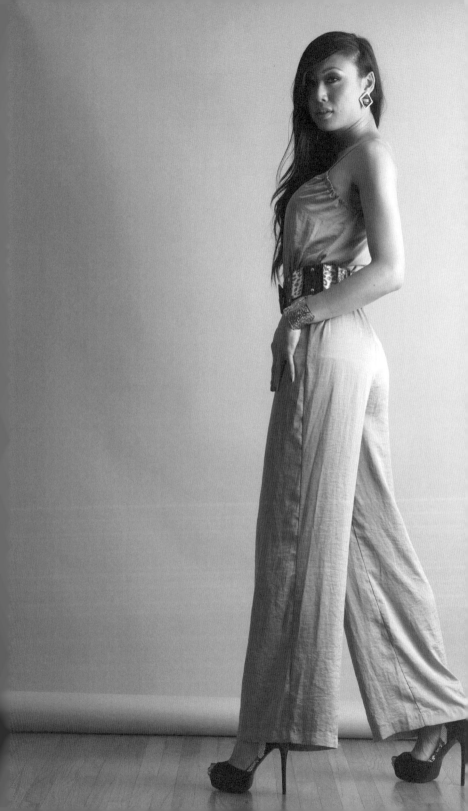

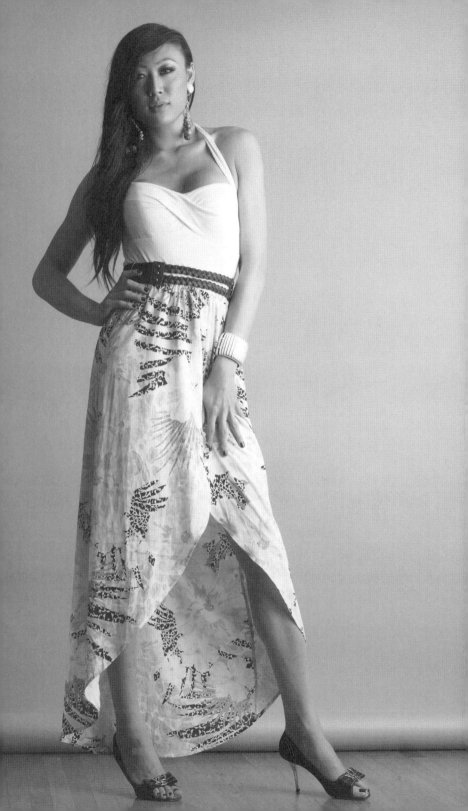

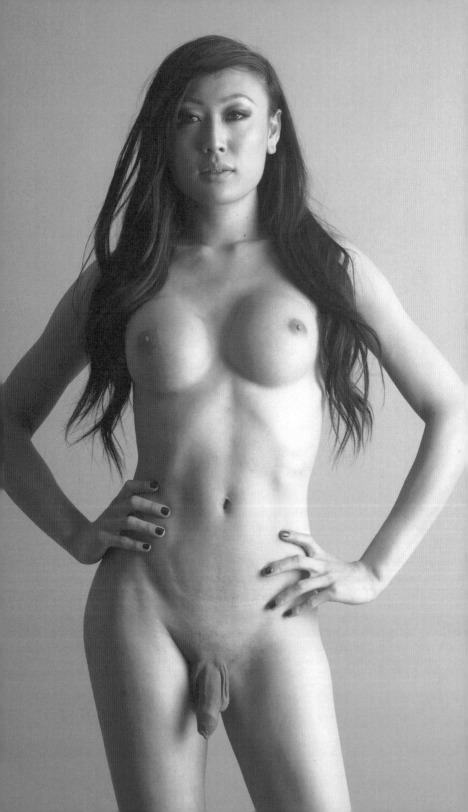

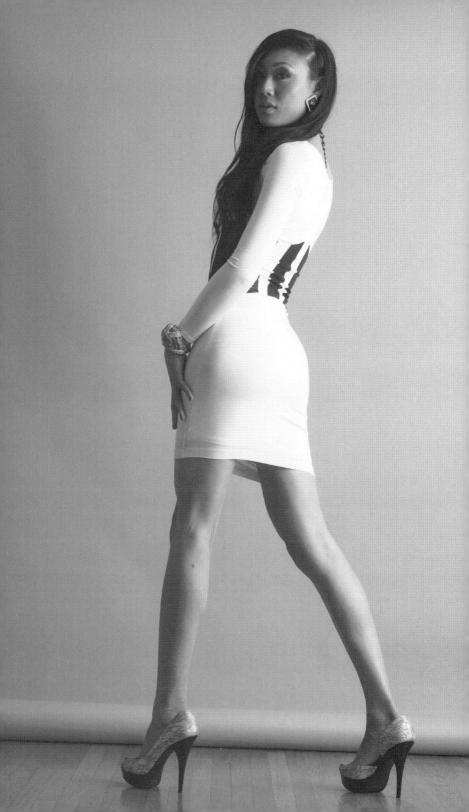

Jane Starr

AN'T STOP DIGGING WITH my nails
It's the only way. Saw you out walking just the other day. Man you were lookin' pretty mean. Like it's so easy. It's so easy coming clean. You really think I'm waking up in paradise? Just cause I put a little effort into dressing nice? And I've got it so wrong.

On fucking everything. Gone off on another manic swing. My meds must not be working out. Oh baby, what's this? Baby, what's this all about? Got your latest texts, I think I counted forty-six. A Chinese laundry list of well-regarded therapists. Maybe you should go line up with the others. You can stand in front right next to my brother for the quietly understated funeral parade. I'm pretty sure they're giving out free drinks. I know my mom could use one quick. Since she's renting out the place. Gotta say I loved your heartfelt eulogy. I swear your writing skills developed so naturally. Did your new friends offer up condolences? Did my old ones compliment the service?

Did this one thing at least go as you planned? I'm sure my coffin was nothing short of grand. Half a decade and six months later, my corpse still makes you hate her, 'cause it's not

buried and she's not in the ground, even worse we're going out in public now. Have you recovered? I know it was emotional. Since that one time you saw me at the shopping mall. I guess I should've had a friend post some flyers first. I didnt know there'd be a jacket sale at Hollister. I'm hecka sorry.

It's just been getting cold and I've been looking forward to skating nights and weekends. I'm just more confident the earlier it's dark now I think you kinda get how that routine can work out. Yeah, so I hear last year got kinda big for "us." Too bad it's really not my deal. You know it never was. If it staved off any deaths (for now) that's a plus. I'm still trying to forget where they're so focused.

It's not like the cops are outlining new bodies. Hey, rookie, that chalk's not cheap. Fucking new kid doesn't know policy. Strictly humans and animals only. No need to bother with forensics. There's a dumpster out back. We've got some matchsticks. Hey, Serpico, here's the fucking car keys. In the trunk there's a rusty can of gasoline. For chrissake don't barricade the traumqueen. You're still acting like there's a real crime scene. So no shit if I'm not that excited. It's just something I've dealt my whole life with. Hope it's livened up your written correspondence. I think it's sweet you and my mom kept in touch. I'm just happy not to hear as many questions only 'cause I star in less recollections. But that's got more to do with time and direction.

Not some magazine cover's affection. Fuck your admiration stares concerning bravery. A year ago you were the kids on the freeway.

Screaming "faggot, hope you bleed out your panties."
You make us sick.

You give us bad dreams.

Now I'm the lucky one.

On my own a little soldier.

Thank god your dad loves Sharon Stone and wants to
blow her. I own *Casino*. It's always been my favorite. I just
bought groceries. And washed the come off my tits. I used to
pray for days of heaven just like this. Second class is a holiday,
you bitch. I'll take that deal vs. lying face down in a ditch.

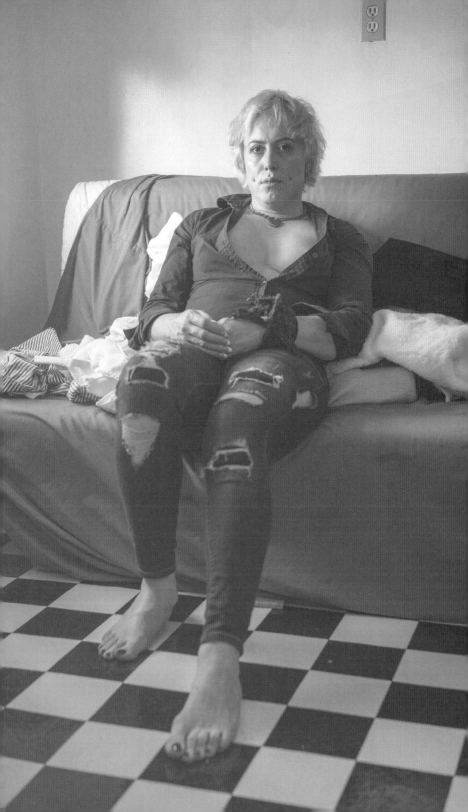

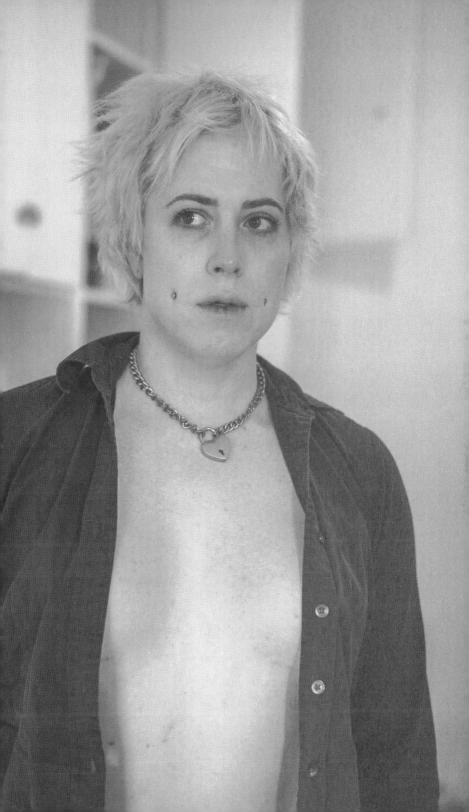

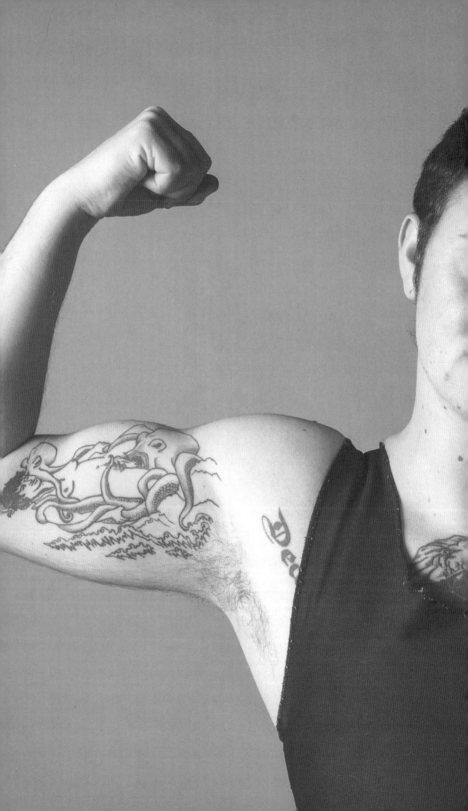

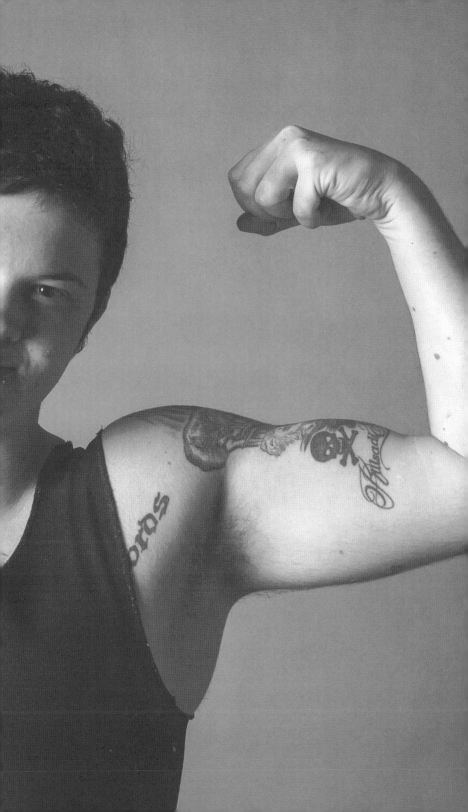

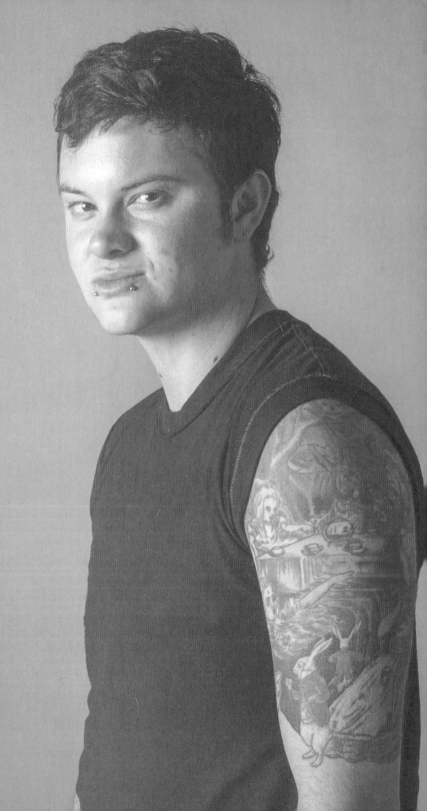

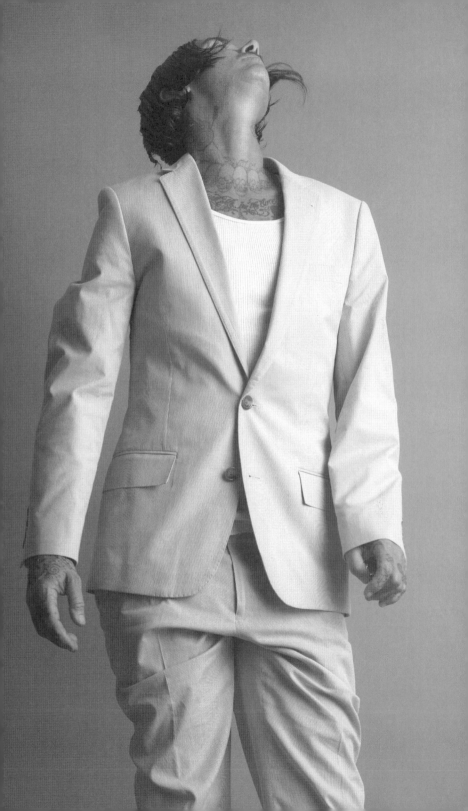

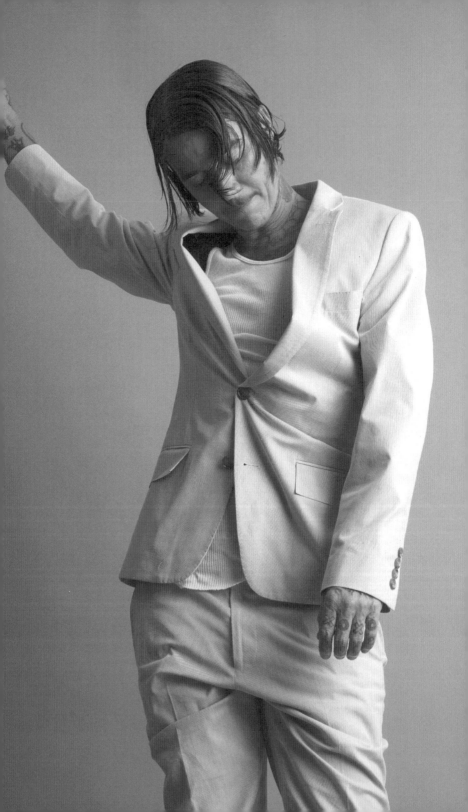

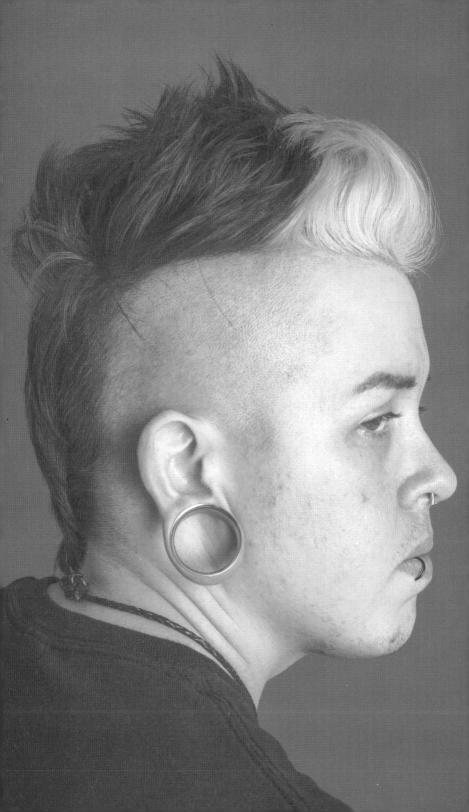

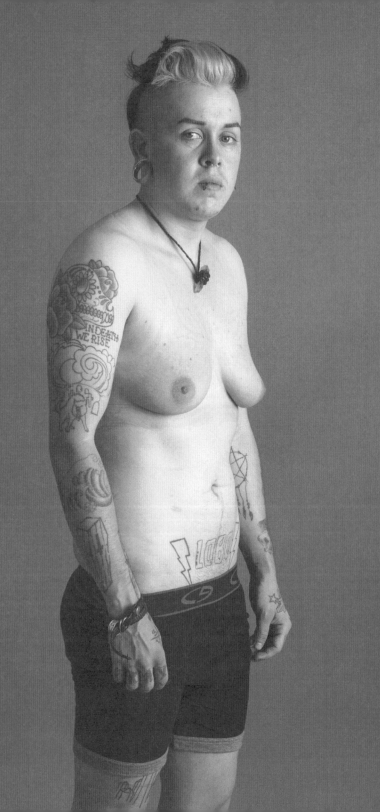

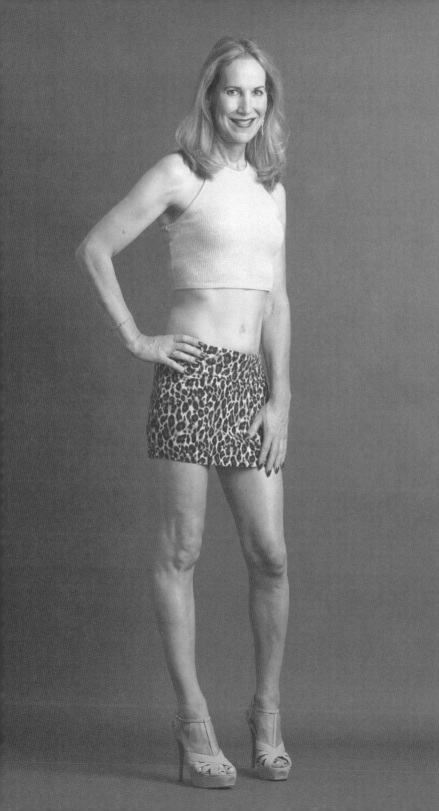

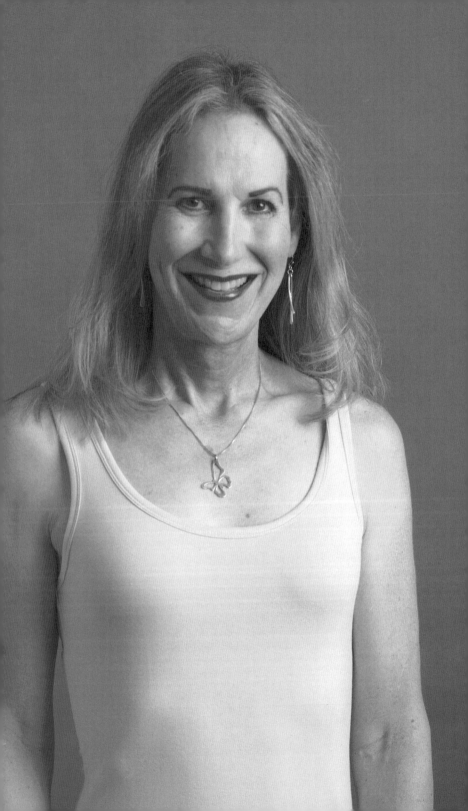

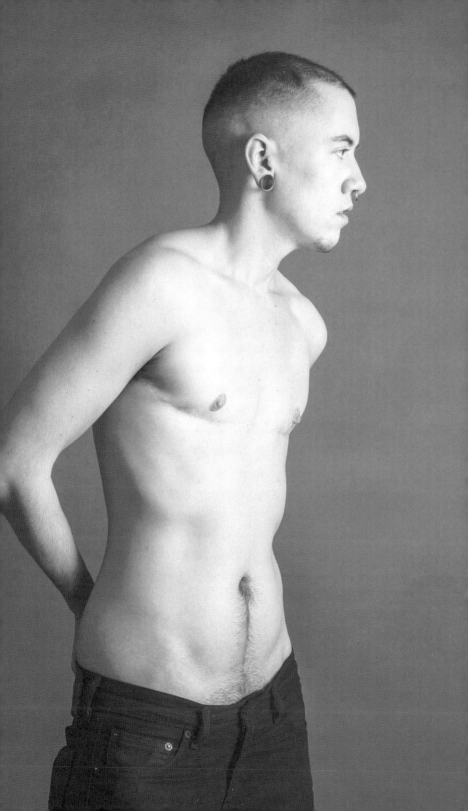

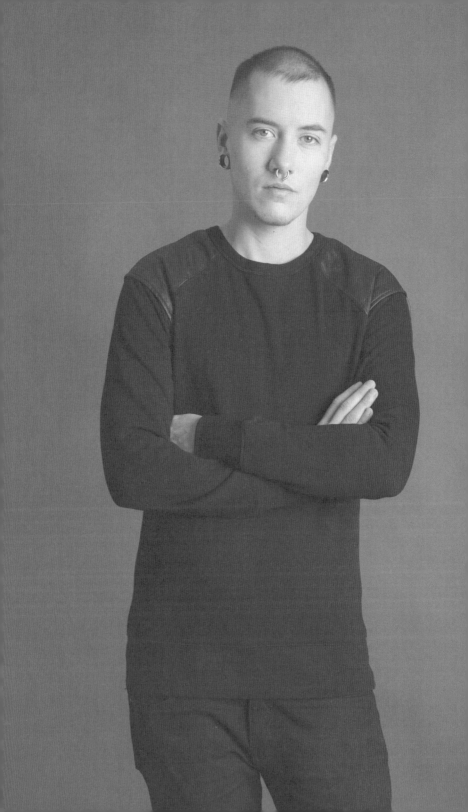

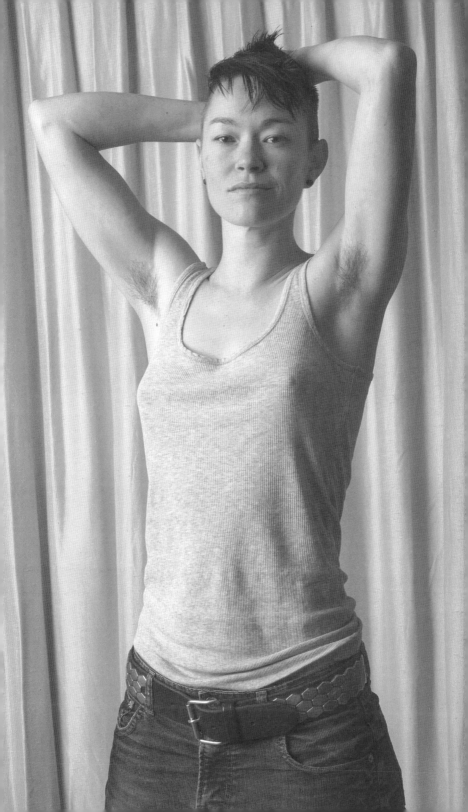

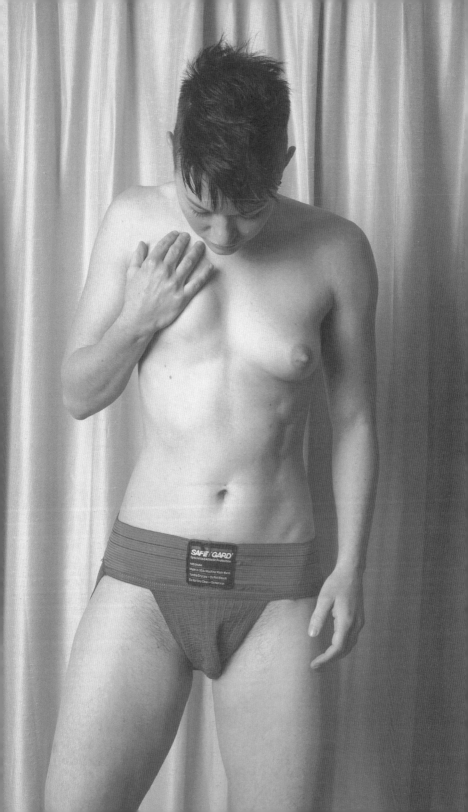

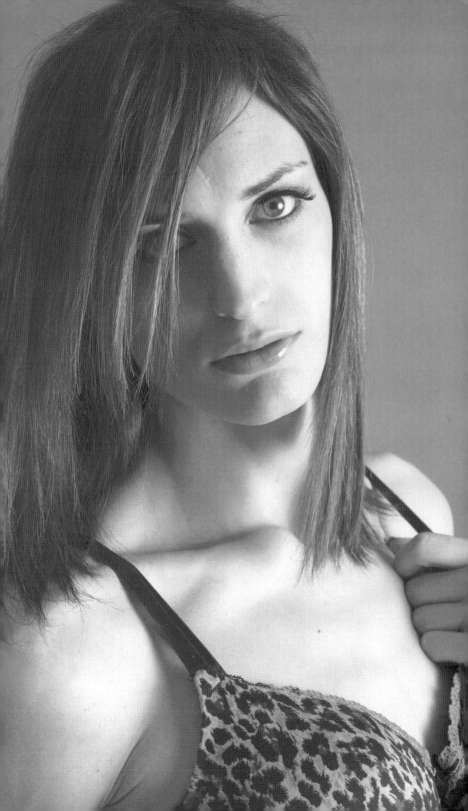

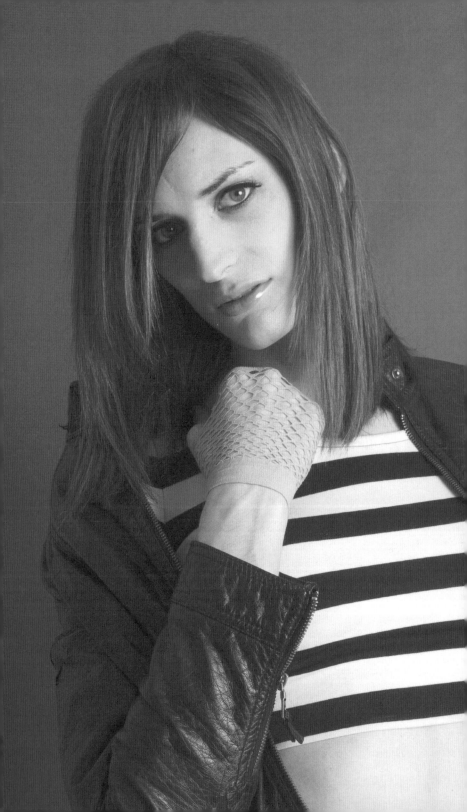

Gender, Consent, and Rape Play
Andre Shakti

OR AS LONG AS I can remember, I've always been into rough sex.

My earliest erotic fantasies involved the boy I had a crush on in seventh grade. A group of us made of habit of visiting the local public library after school to study. When I crawled into bed at night, I'd often touch myself while imagining the object of my desire catching me alone between aisles of newspaper archives, shoving me up against the shelves, and forcing his mouth onto mine. Later, this same boy and I would share the newfangled wonders of the Internet with each other, sending links and clips of pornographic content featuring "forced sex" themes back and forth in titillation.

When my genitals weren't occupied with video stimulation, I'd get my brain hard by devouring amateur online erotica. While the plotlines and casts of characters differed, the gist was always the same: Big Bad Man coerces, entraps, and overpowers Small Vulnerable Woman. Exhausted—yet effective—archetypes. Usually the man was in a position of power over the woman. Her boss, her father, her college professor—I wasn't picky. More often than not, at some point during the rape, the woman would begin to—reluctantly—

experience pleasure. She was almost always shamed and ridiculed for it. My favorite scenes to read and watch were, by far, nonconsensual group gang-bangs. Many men, one woman. They were guaranteed to give me an extra thrill.

Though I was raised relatively conservatively, my deviant habits never gave me pause. I had never been a "good girl," and had no interest in playing one on TV. As such, I had no qualms about exploring and embracing my desires. Unfortunately, being a dominant personality myself, I hardly ever attracted the kind of confident, assertive male partners who I imagined might help me physically explore these fantasies. When I thought about acting out one of my rape fantasies with someone, I always maintained that the person had to be the perfect combination of "safe" and "convincing." My boyfriends tended to be sensitive, quiet, and kind, known way more readily for their brains than for their brawn. I came close to asking a few high school sweethearts to hold my wrists down while we fucked, but never pulled the trigger.

Once I came into my queer identity in college, though, everything changed.

The evolution of both my queer identity and my kinky identity came hand-in-hand. My first transgender partner was also the one to formally introduce me to the BDSM community when I was barely old enough to drink. They were unwaveringly patient, knowledgeable, communicative, and loving. I had already been dipping my toes into the sex-education sphere, and before long the two of us were attending, producing, and teaching at both large-scale kink

events and intimate play parties alike. We became a slutty dynamic duo.

I discovered that I was really into getting fisted, choked, and hit with blunt, thuddy objects—like fists—during sex. I had always been turned on by wrestling, and though I wouldn't receive formal training until my mid-twenties, I would throw cute queers down on thick dungeon mats faster than you could blink. I learned how to throw a flogger, realized that I really liked wearing a strap-on cock, and expanded my dirty talk repertoire.

Although my partner was all too happy to beat me up and toss me around at my request, it still took me over a year of dating them to broach the rape play conversation. The desire was there, but my mind kept hitching on a single detail: I was afraid they wouldn't be convincing enough. When I fantasized about getting taken by force, it was always by the archetype that porn and erotica had conditioned me to expect: a big, surly, cisgender man. Despite my partner's formidable skill sets, they were still a short, androgynous, genderqueer person with a kind face and a wide smile. I doubted that they could instill the delicious shivers of fear that I felt in my fantasies.

At some point I had this conversation with my partner, and a few weeks later we attended a kink event together. Walking to one of the dungeons to meet them after dinner, I was jumped in the dark by a tall, strange man in military camouflage. He wrestled me to the ground and gruffly scolded me to "take it easy and be a good girl" before pulling a hood over my head and throwing me over one shoulder. I was being abducted, and I knew exactly who had initiated it.

That didn't stop me from being terrified, however. I've never been a victim of sexual trauma or assault, but as someone socialized female from birth, I carry around a healthy dose of disdain for and apprehension toward men. As much as I'd always desired men, so too have I always read them as potential harbingers of violence.

When we arrived at our destination, I was thrown roughly to the ground, my hood abruptly peeled off. As I adjusted to the lights, the faces of over a dozen people came into focus. Not only had my partner coordinated a surprise abduction for me, but apparently a surprise gang-bang was to follow. My partner had done their due diligence in inviting folks that they thought I would find attractive. They were also mostly people who identified as masculine-of-center on the gender spectrum, either "tough-looking" transmasculine folks or cisgender men. Instead of my panic being mollified, it only intensified.

My partner suddenly hovered over me, making eye contact—a nonverbal check-in. I could have used a safe word, held up a finger, or gently shaken my head side-to-side to indicate my angst. I did none of these things, and to this day I have no idea why. Was it because I didn't want to embarrass my partner? Was it to protect my own ego? Or was it a more intentional challenge to myself, to see how I would respond to the scene? Whatever it was, I nodded consent, and spent the next hour being forcibly gang-raped. Consensually? Non-consensually? Like most things, it remains firmly in the gray matter.

This is when I discovered that there is such a thing as "too convincing." This is when I discovered that some fantasies, no matter how frequent or intense, deserve to remain in the mind.

I discovered that my aforementioned disdain for and apprehension of men ran deeper than I ever thought it could, and for good reason. Violence against women, perpetrated and perpetuated by men, was too real for me to turn erotic in a tangible way. Having sex with women and trans people felt secure and comfortable, no matter how rough the play got. I never worried that they would "lose control" or accidentally hurt me. As I was being fucked by men during my gang-bang—hell, from the moment I was jumped and wrestled to the ground by the man outside—those were very palpable anxieties of mine. Throughout that hour—one of the longest of my life—I intermittently believed I was getting raped. And it wasn't sexy at all.

There were weeks of processing and aftercare following my first forced sex scene. Months later, when I decided to revisit my fantasies, I approached my partner directly and asked them to forcibly top me. I was no longer concerned about them—or anyone—being "convincing" in their role. I just wanted to feel safe while still getting my sexual needs met. They did, it was amazing, and the experience empowered me to verbalize my desires to all of my queer female and trans partners from that day forward.

Now, I treat gender as one of my favorite sex toys. I can safely and pleasurably explore all kinds of rough sexual play, psychological manipulation, objectification, and other aggressions that are an eroticized mimicry of the actual

dangers women face simply by walking out of our front doors every morning. I just need to have a non-cisgender man at the helm of those experimentations. My female and trans partners have roleplayed "The Boss," "The Stepdad," and "The Bro" to my great satisfaction, and only because of the undeniable distance between who they actually are and who they become to embody those characters.

Perhaps when the world becomes a less scary place to live in for women and trans people, I'll invite a man to take me by force. But I'm not holding my breath.

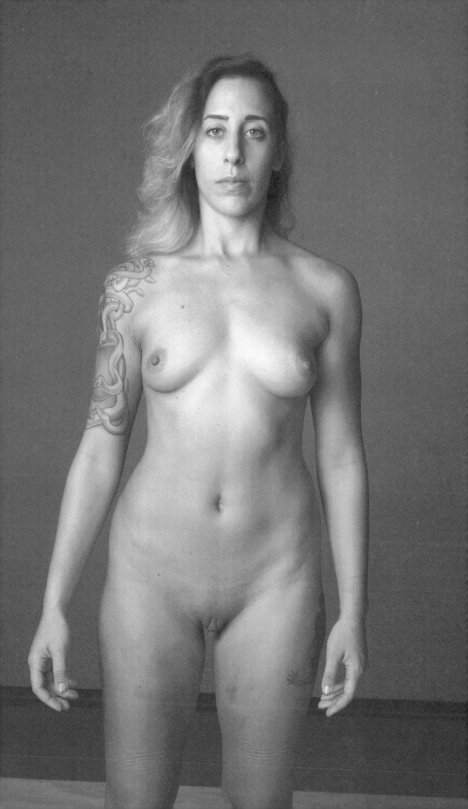

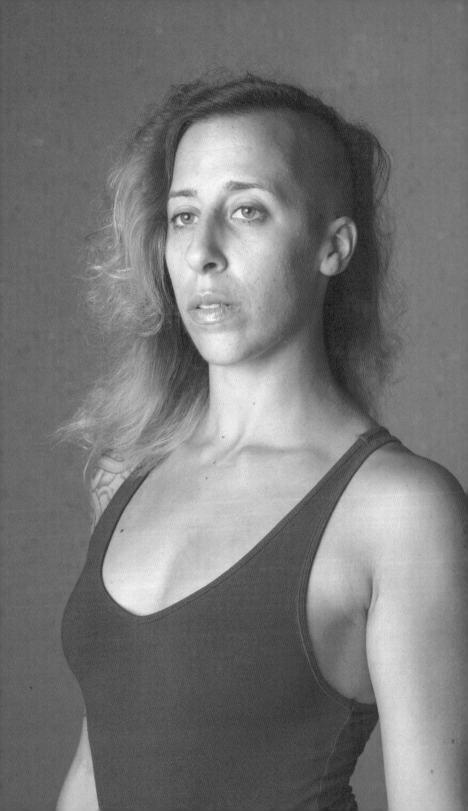

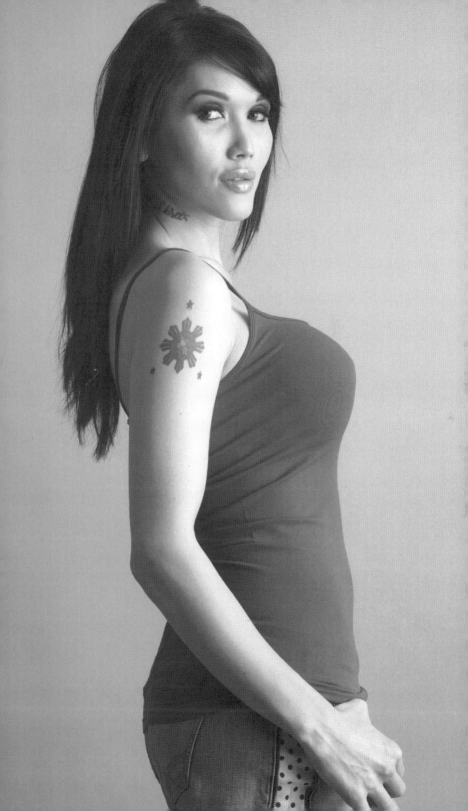

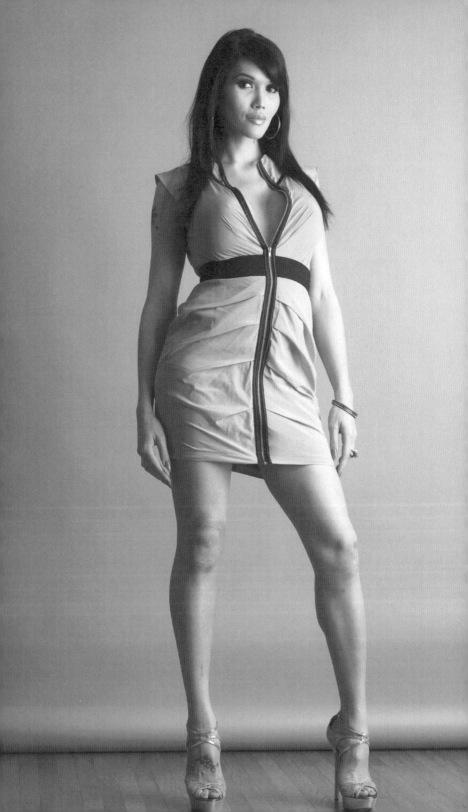

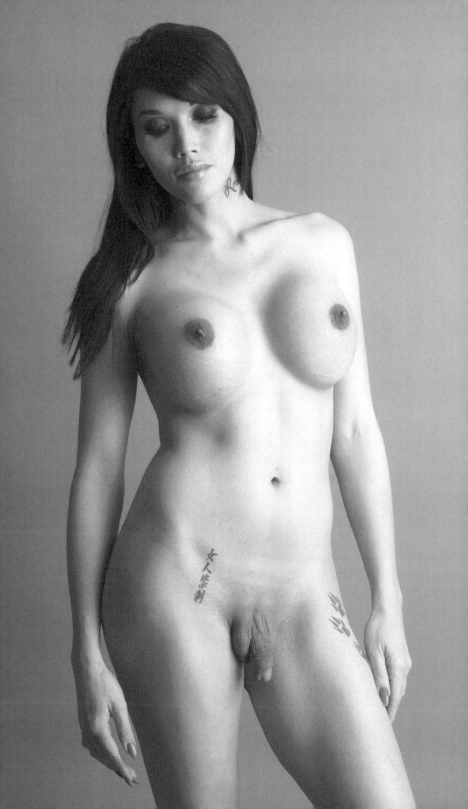

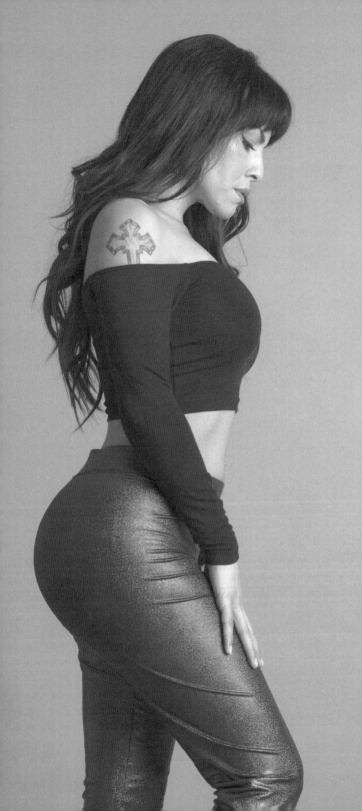

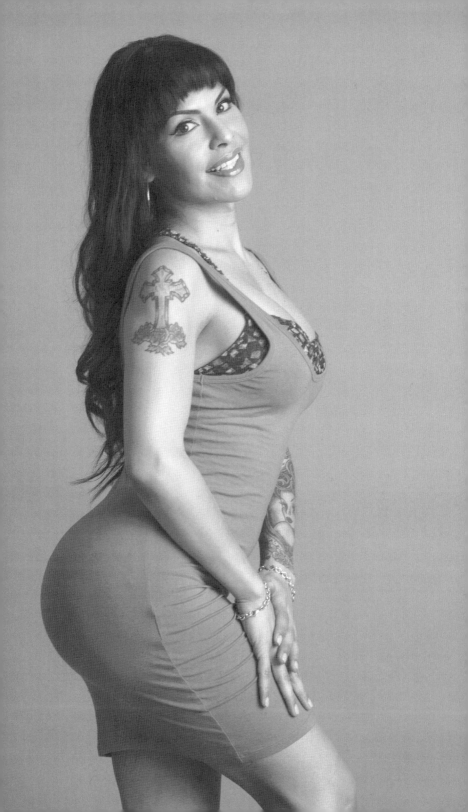

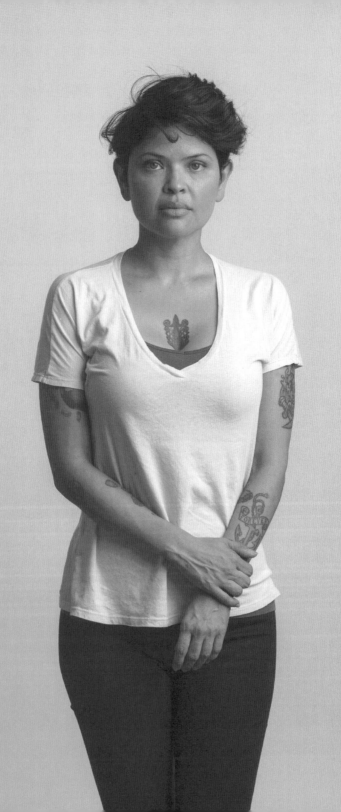

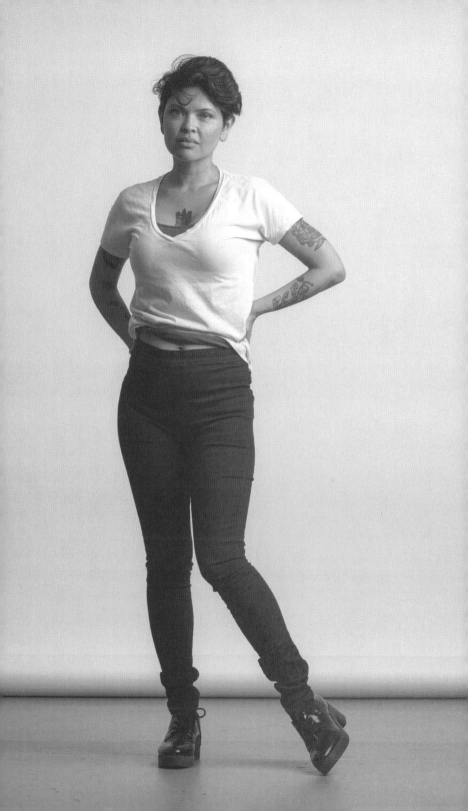

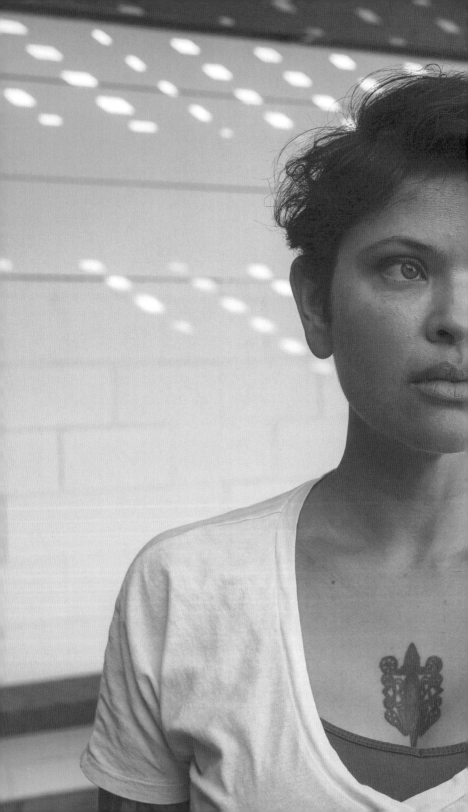

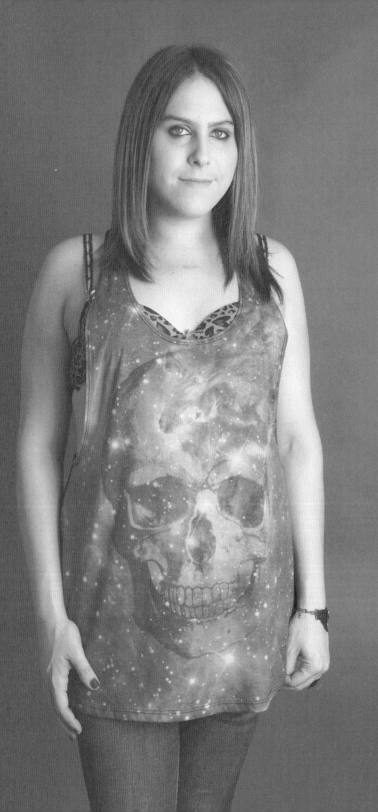

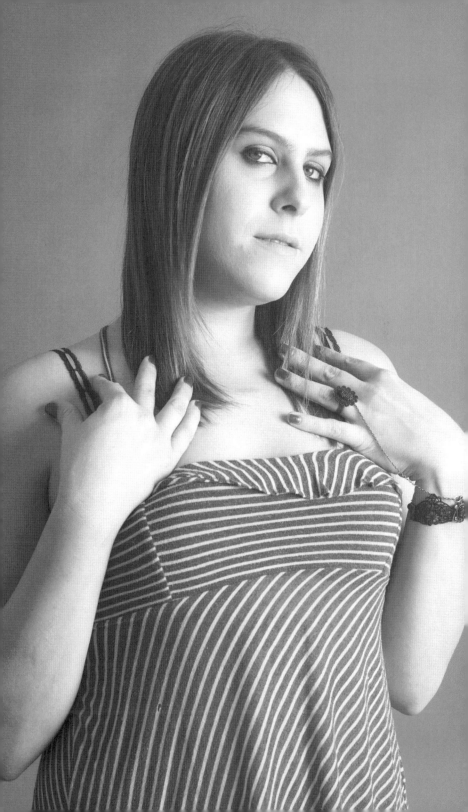

Matty Boi

MY PARTNER AND I love going to the movies. At least once a month, we treat ourselves to a nice theater night with dinner at the Alamo Drafthouse in San Francisco's Mission District. Until we moved in together, she lived about five blocks away and it was always nice to walk there, maybe stop in a couple of shops and enjoy each other in the city we both love. Sometimes we dress up, sometimes we don't even bother to take off our sweatpants. But on this particular night, she looked absolutely stunning and we were truly feeling those butterflies in our stomachs while looking at each other.

That night after the movie, we started to walk home. It was after dark on a weekend, so there were quite a few people around the neighborhood. But once we turned up the side street to walk up to her house, it was just us and a guy changing a tire on our side of the street. I felt a little nervous, so I grabbed her hand while we continued to walk. After we had already taken a few steps past him, I hear "Hey, can I use your phone for a second?" I started to get increasingly nervous and turned and said, "No, sorry." We continued to walk, hoping that would be the last we'd hear from him, but

soon after he was addressing my partner more aggressively about borrowing her phone. She quickly and powerfully responded, "No, I'm a female walking at night and I'm not going to stop and help some guy I don't know!"

And that's when it happened. He reacted.

"You know what? Fuck you, you cunt! Fuck you, you stupid bitch!"

She responded angrily and loudly, as she should. "Fuck you! Men like you are the reason we have to be afraid of men."

I just shut down. On the outside I was shaking, with pursed lips and clenched fists, trying not to cry. I grabbed her tightly and walked faster up the street still listening to him continuously yell obscenities at us until it faded in the distance. My internal dialogue was like two opposite personalities screaming at each other. One side was screaming, "How are you letting this guy speak to her that way? Go handle it. He can't just get away with speaking to women that way. Stand up for you guys. Why are you so scared? Don't be a wimp." On the other side, there was a more familiar and justified perspective. "Just keep walking. If you walk fast enough, he'll stop. Don't say anything, you don't know how violent he may be. Don't put you and your partner in danger. He may rape you. There's no way you could win in that fight. Just keep walking as fast as you can. Is he following us? Does he have a weapon? If you talk, make sure you drop your voice so he doesn't know you're not cis. Just keep walking." I shook with anger and fear for a solid hour after that. This is probably the thousandth time I've been in a situation like this, but for the first time since I had surgery and started to grow facial hair,

I realized that the tables had turned. I wasn't the one who needed to be nervous when I walked home alone anymore. When I speak to women do I make them panic like that? It hit me hard. I felt sick.

I was now the person women were nervous about.

◆

I GAINED AND LOST a lot by transitioning. Some of the things I gained are personally healing and ultimately saved my life. I'm finally comfortable in my skin and I look the way that I feel on the inside. I feel more confident than I ever have. I'm happy and healthy. I live in a place where I'm able to be on hormones and have access to a supportive community. I no longer feel unlovable every day when I look in the mirror. I'm incredibly lucky and I do not take that for granted. Those are the things I was seeking when I came out. I was seeking comfort and alignment in my body and mind, and that's what I got. But along with that came "privileges" that feel more like consequences.

When I made the decision to physically transition I had been out for almost ten years. I had evolved in so many different ways when it came to my personal identity that by then I had experienced how the world treated a number of different perceived identities. I had walked through the world as a straight tomboy, bisexual, butch, androgynous person who dated and slept with women, an unsure trans male, a masculine trans male, and a feminine queer trans male. Incorrect assumptions haven't ever bothered me, unless it's the assumption that I'm a misogynistic straight male. When

men feel that unspoken bond and feel comfortable saying awful things about women in front of me, or when I see women nervous when they're around me by themselves, it can really take a toll. I never even considered how much my behaviors were going to have to change when I was no longer being seen as female.

So now, as I walk through the world with a much wider view of how the world treats different identities, my social interactions have had to change. I often feel a huge loss of intimacy with women who don't know I'm trans. Unless they think I'm a gay man, they're guarded and question my motives (rightfully so). All the while, like on that night after the movies, I'm still afraid of cisgender men. I still get scared on the street at night or when they talk to me at the bar. I feel like I always have to be agreeable with men in order to not be seen as "argumentative." I'm afraid of being assaulted and raped. I'm afraid in the exact same way I was before, only now that I'm perceived as male I'm no longer as vulnerable as I once was. And now, I'm the person women are wary of when I in fact share the exact same fears.

I know what it feels like to be afraid of a man on the street at night. I know what it's like when a man hugs you for too long and you feel obligated to just smile and deal with it. I know what it's like to be spoken over and have my opinion be less important than my male coworkers. I know what it's like to be intimidated when a man wants to buy you a drink at the bar. Sometimes I even feel ashamed to identify as male now that I've seen what goes on behind closed doors. But I've been given a rare opportunity that most people will never have; I

can fight from the inside. I can teach men how their actions make women feel. I can share how those kinds of actions affected me. I can shut down "locker room talk." I can speak up for women, from a woman's perspective, with a voice that for some reason holds more value to the rest of the world. I'm taking advantage of this uninvited privilege to put value in my place in society. I may not be able to change the way men are when I'm not there, but I can use my place in the world as much as possible to stop misogyny in its tracks.

"Men who want to be feminists do not need to be given space in feminism. They need to take the space they have in society and make it feminist." — Kelly Temple

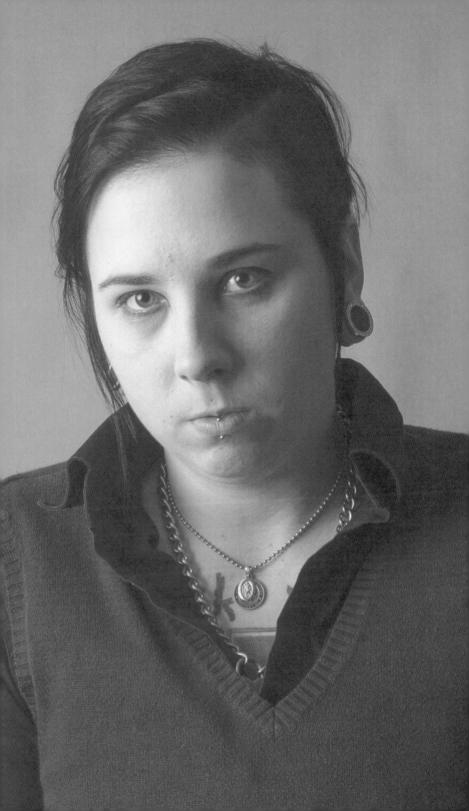

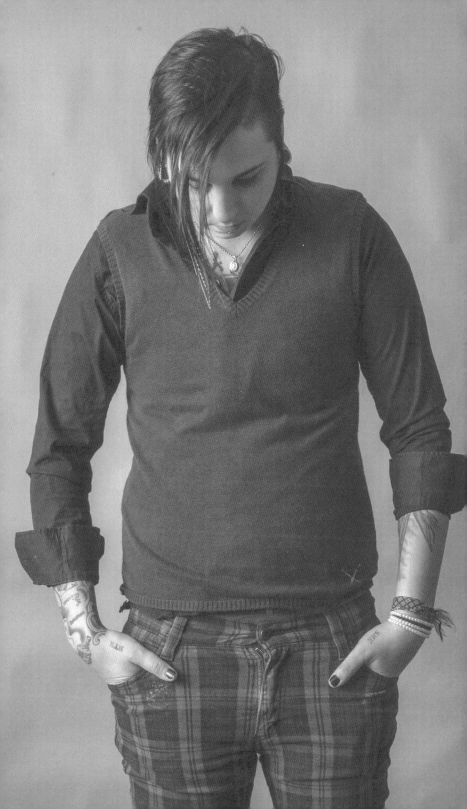

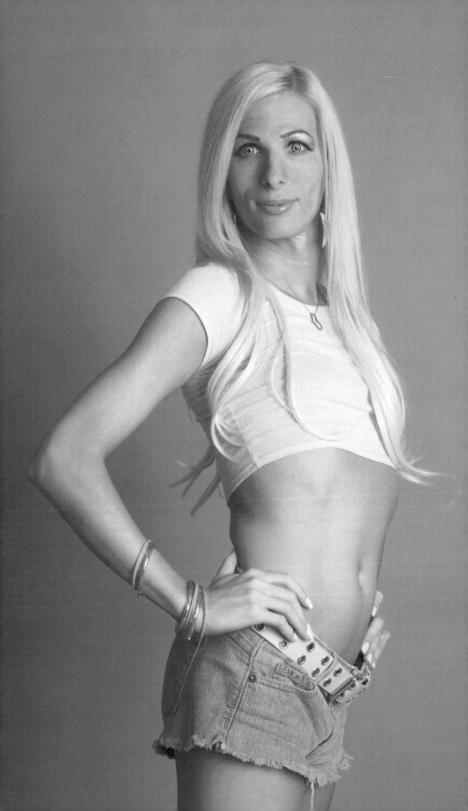

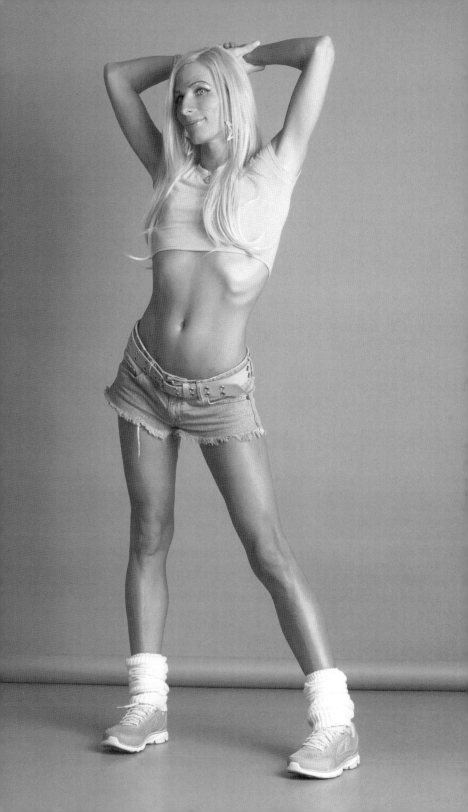

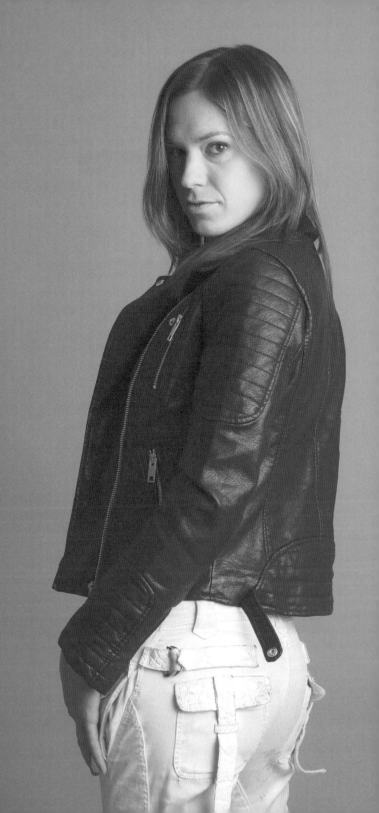

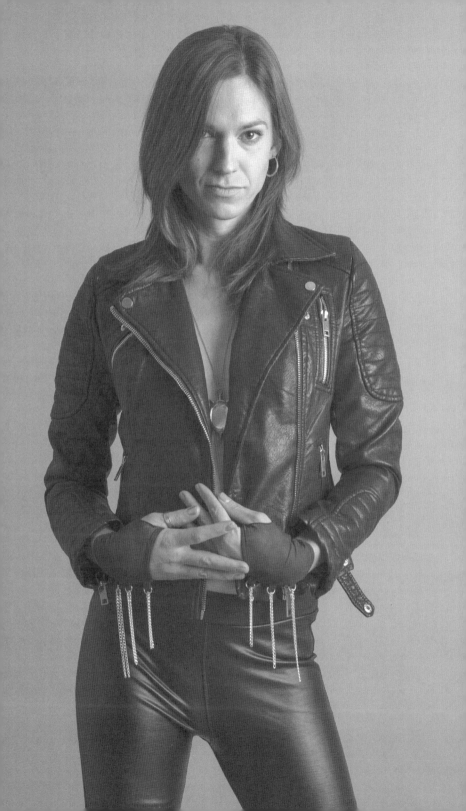

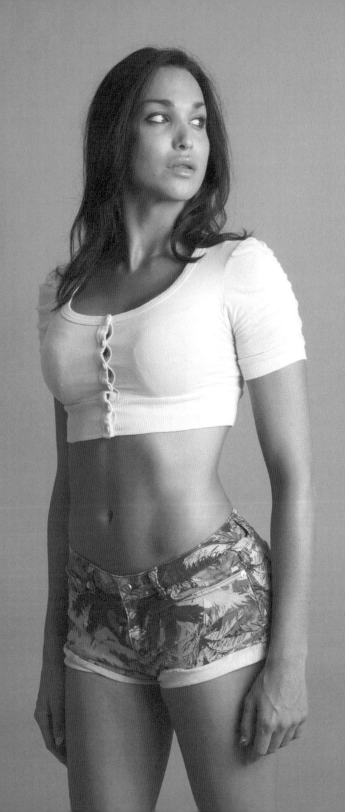

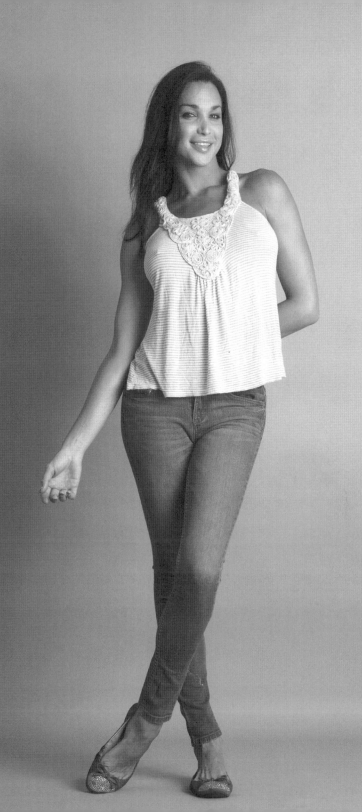

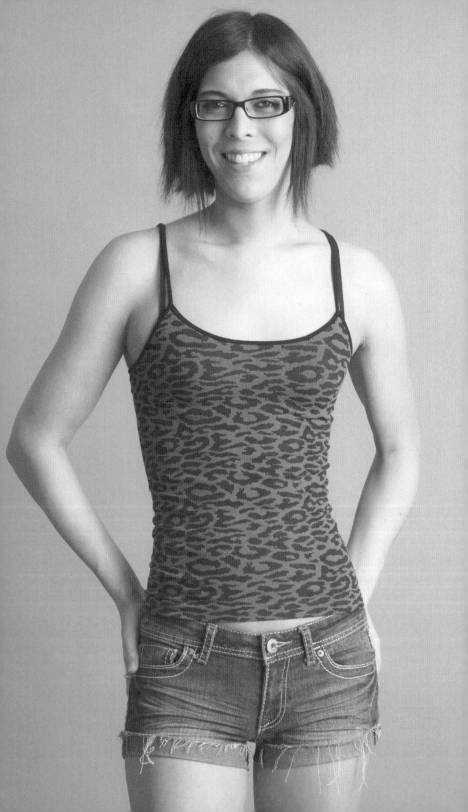

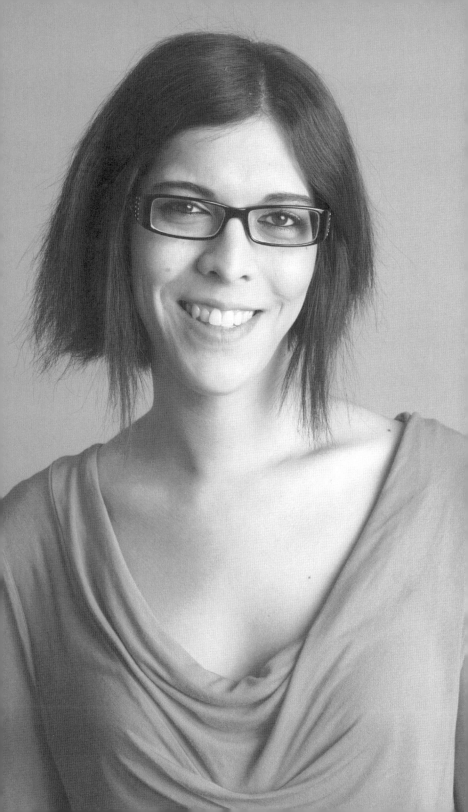

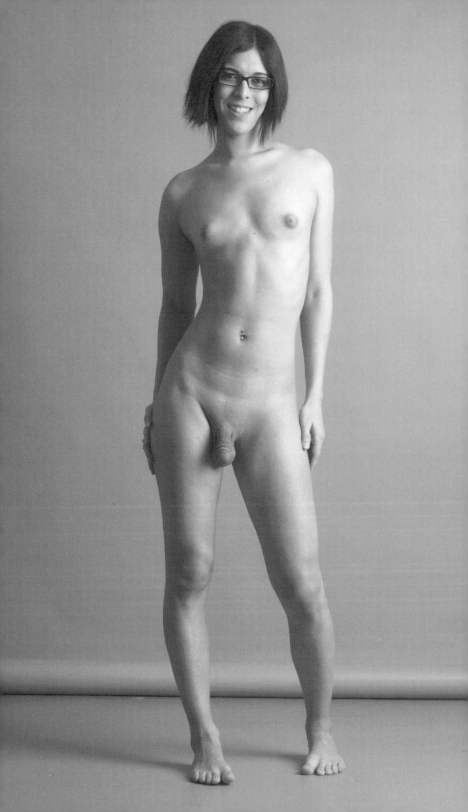

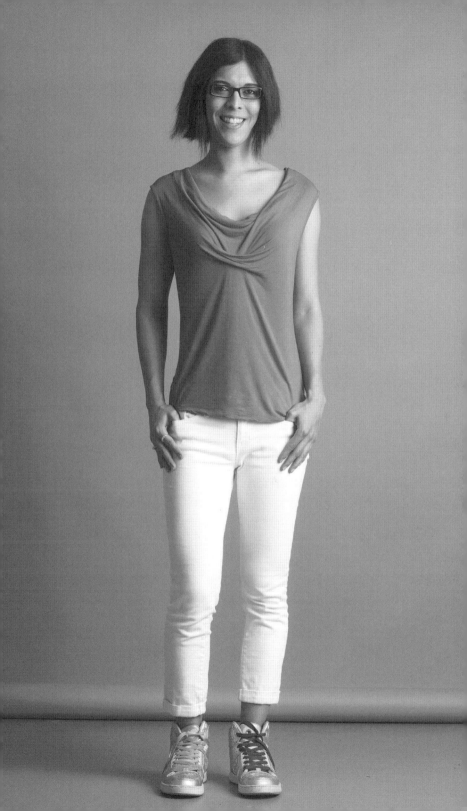

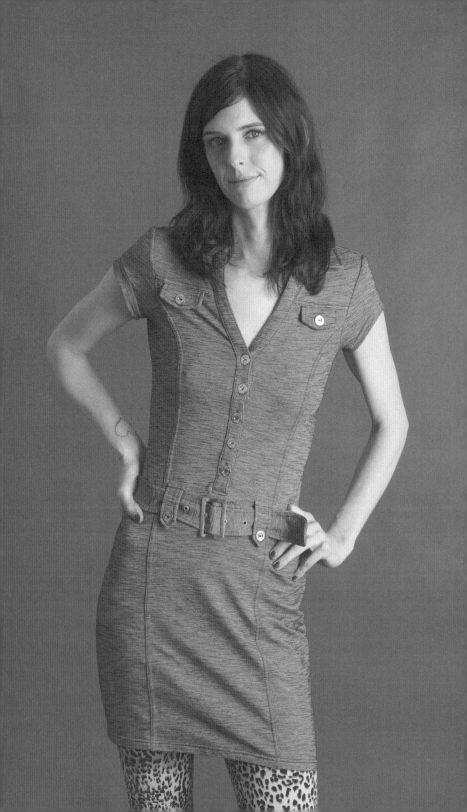

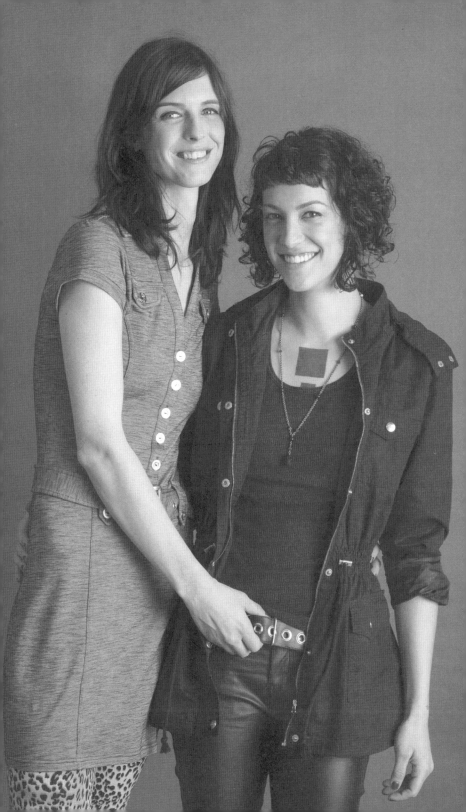

The First Time I got Fucked in the Ass
Kelli Lox

WHEN I WAS NINETEEN, I was living in Oregon. I was in college, and I had a steady girlfriend. Back then, I was a boy. I knew that I was transgender, but during those years, I kept it a secret. I remember I would buy girls clothing and pretend it was for my girlfriend, and when nobody was home, I'd dress up, shave my body hair, paint my nails, put on jewelry, and so on. One day, I dreamed up a trip to British Columbia, Canada, that would provide the perfect opportunity to explore my fantasies without anyone finding out. The official story was that I wanted to visit a college in Vancouver. As I packed my truck and said goodbye, my girlfriend suspected nothing. Inside, I was electric with excitement.

At that time, I had already been playing with anal toys. I mean, we had some sex toys that I secretly played with when she was asleep or whatever. So my asshole had been stretched out a little bit. I loved the feeling and fantasized endlessly about getting fucked for real. I had never been with a guy before. I was not interested in guys. I liked girls. The only thing I wanted more than fucking a girl—was being a girl.

And once I was a girl, I imagined, a guy would be attracted to me and fuck me like a girl. Does that make sense? It made perfect sense to me, and as I drove north across the border, I imagined a multitude of sexual scenarios that I might experience in Vancouver, to the point that it was difficult to concentrate on the road.

I found a cheap hotel in the grimy downtown area. I showered, shaved off my body hair, painted my nails, and put my longish hair into a high ponytail. Remember, this was long before I started to transition—I had basically no idea how to dress like a girl. I did, however, have my ears pierced already, and so I put in some cute little earrings. For a top, I wore a black camisole tank top. It wasn't very sexy, but it was definitely girls clothes—not boys clothes—and that's what mattered to me. A girl's hoodie and girl's casual pants rounded up the outfit, and I left my hotel and walked to a club. So I'll admit—I didn't look like a girl. But I certainly looked like a girly boy, and that was enough for me. I figured that, while I was still playing it safe, anyone who looked closely enough would be able to tell what was going on. As I walked down the street, all I could think about were the cute black lycra panties I was wearing underneath. The thrill of walking around in panties, looking girly, in a strange city, was intoxicating.

At the club, I chatted with a cute girl. She said that she was modeling/performing in a few minutes. Apparently, some friends of hers owned a BDSM-inspired line of clothes and accessories. The show consisted of boys and girls in the clothes simulating BDSM activity. It was pretty tame, but

still pretty hot. Afterward, I tried chatting up that girl some more, but she was with her friends and lost interest in me. I realized that I had been fantasizing about going home with her, and imagining how she would react when she saw my panties. I let it go and finished my drink. I didn't find anyone else to talk to there, so I left.

Right outside, on the sidewalk, a really hot girl asked me if I wanted some company. She was the first hooker I had ever met. It's funny, because now I see things from her point of view. I mean, we can tell when a guy can afford it, and when a guy can't afford it but wants to talk about it as if he can, just for the thrill of talking about it. Well, I could not afford it, and wanted to talk about it anyway. If I were her, I would have completely ignored me at that point — and that's what she did. So I started walking back to my hotel, wondering if my big opportunity for sexual adventures in a strange city would amount to nothing. Oh, well. It was already past midnight. I continued walking.

And that's when it happened. A voice called out to me and I turned to see who it was. It was a guy with longish blond hair, a warm smile, and just the right amount of scruffiness on his face. He asked me if I wanted to smoke a bit, and I was like, "Sure!" He led me into his building and we got into the elevator. Once we got to his apartment, it wasn't long before we found ourselves in his bedroom, sitting on his bed. Eventually the conversation turned to my obvious girliness. I told him about my sexual fantasies, and before you know it, we were making out. In my mind, I was the girl. And he was kissing me, and holding me, as if I were the girl. I loved it!

He pulled my pants off and there, in all their cute black lycra glory, were my panties. And he smiled and said "I knew you were wearing panties. I could just tell when I saw you and that's why I called out to you." Who cares if it was true? It was a turn-on. I started sucking his dick. And as he was about to shove his hard cock into my waiting asshole, he gave me this look that said, "Are you sure you're ready for this? You know it can hurt if it's your first time, right?" And I told him that yes, I was ready. Slowly, he put the tip in, and gradually moved it back and forth, and then he squirted more lotion on his hands and lubed up his dick some more. As his cock fully entered my ass and went deeper and deeper, I relaxed, and he was able to build up to rhythmic and steady gentle thrusts. I let out a little moan of pleasure, and he grabbed me and flipped me over, and we tried another position. It was wonderful. We fucked good and hard, deep and passionately, for what seemed like hours. He said that fucking me felt just like fucking a girl. Hearing those words changed my life.

Afterward, we sat naked in his bed, curled up in the blankets and each other, and we read from one of his scripts. He was an actor, you see. I will never forget looking at him, listening to him read his lines in the voice of the particular character, with the night sky dreamily turning into morning outside the window. It was very sweet. He wrote down his number, and tried to get me to promise that I would call him. He said that I should move to Vancouver. He said he'd take care of me. He was being serious.

Eventually, I got dressed, we kissed goodbye, and I descended in the elevator and left his building. By the time I

got to my hotel parking lot, the sun was creating a soberingly bright haze in the downtown air. I took, from my pocket, the little piece of paper that had his name and phone number written on it. And I threw it in a dumpster. I walked into the hotel building, went to my room, and slept.

I think about this story all the time. It means a lot to me. But this is the first time I have ever told it to anyone.

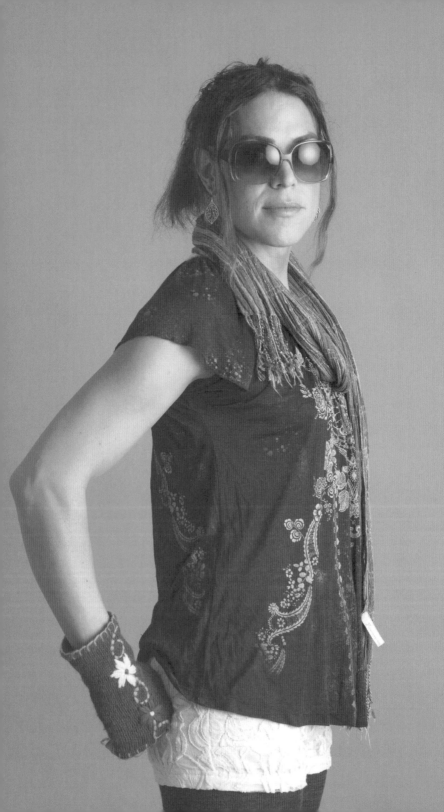

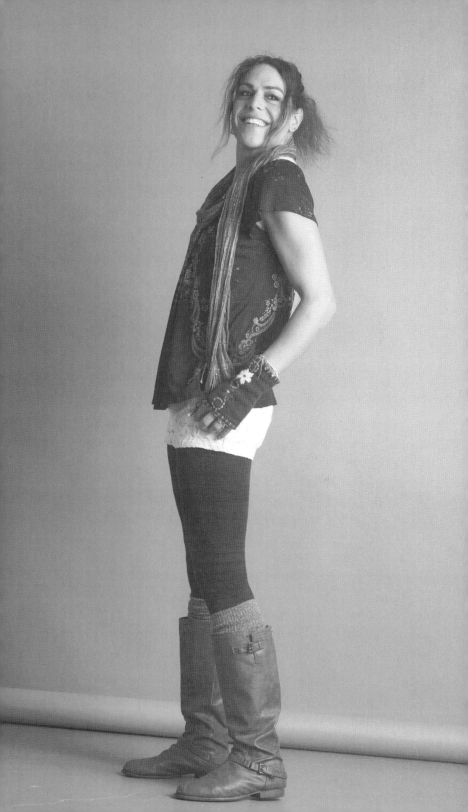

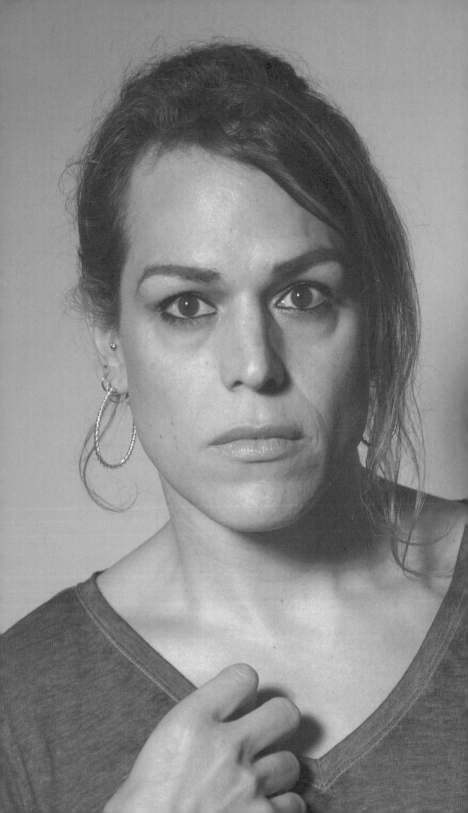

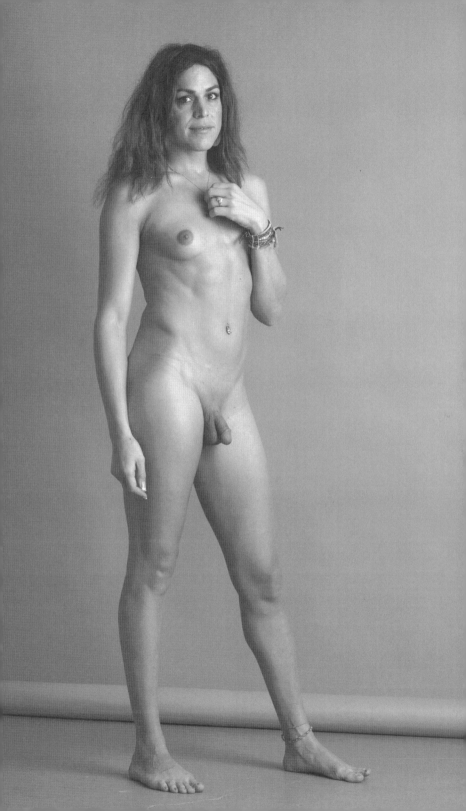

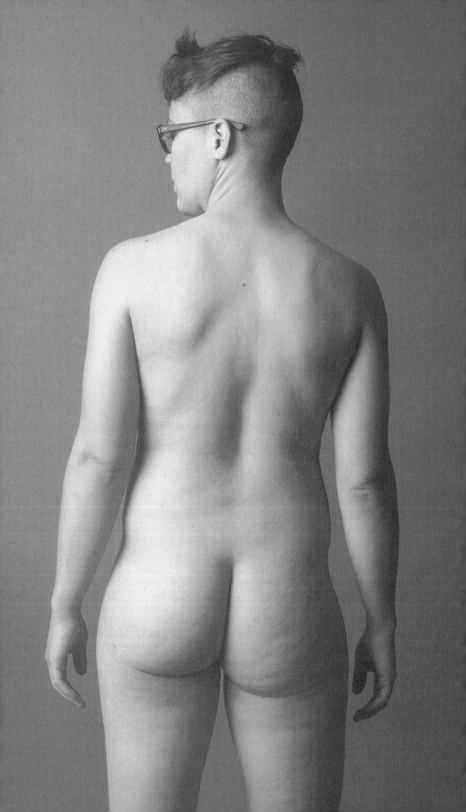

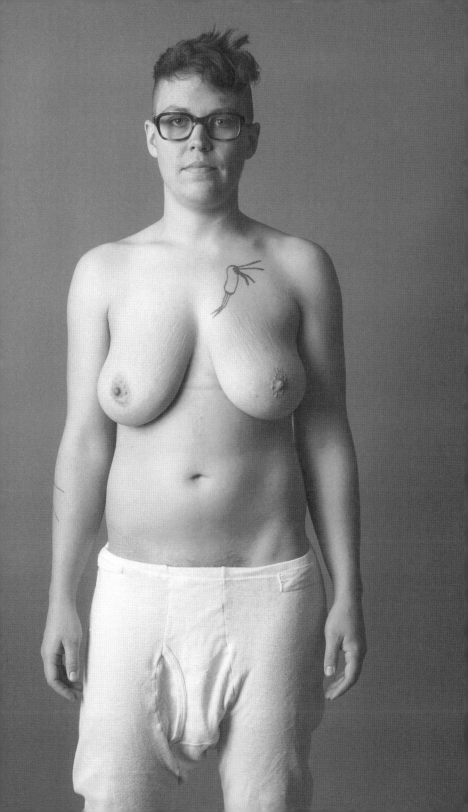

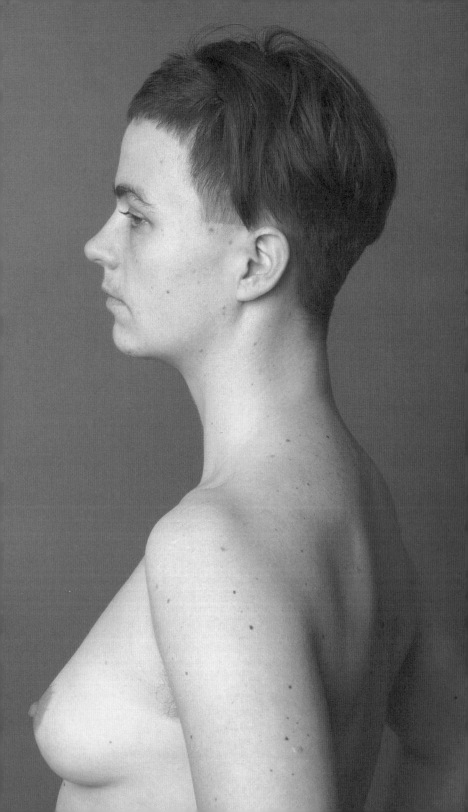

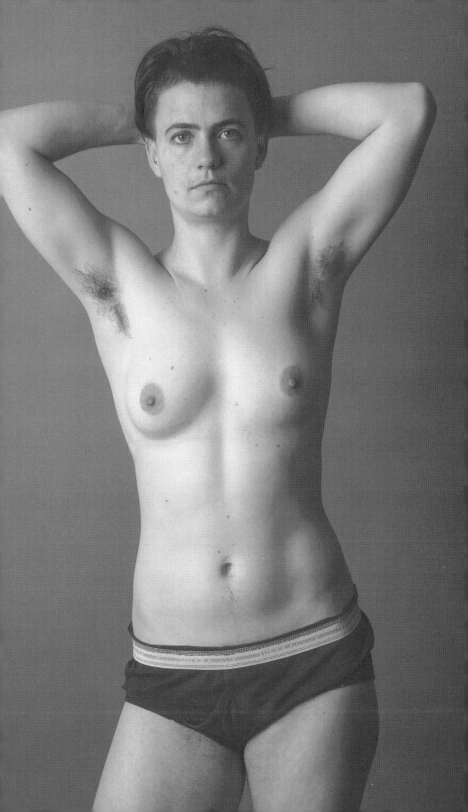

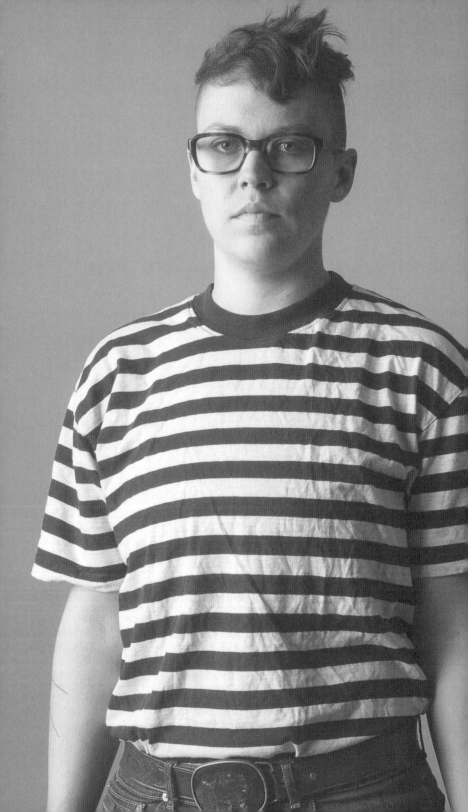

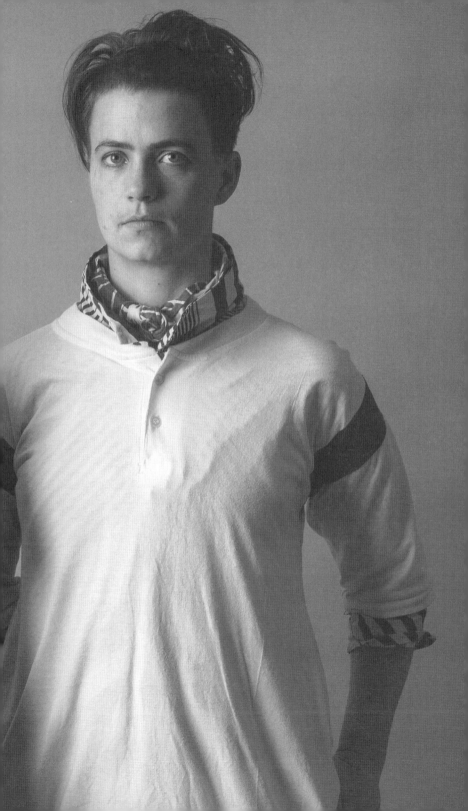

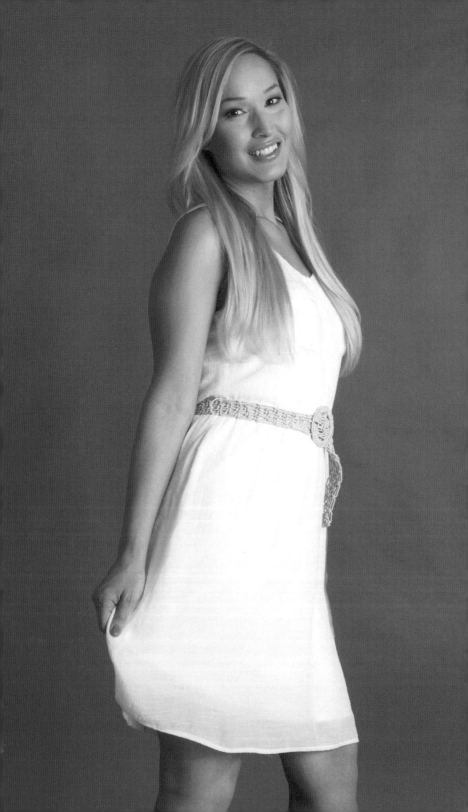

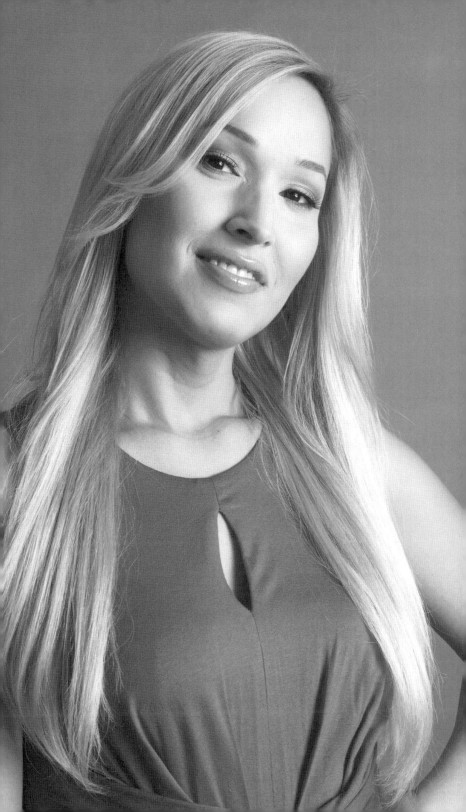

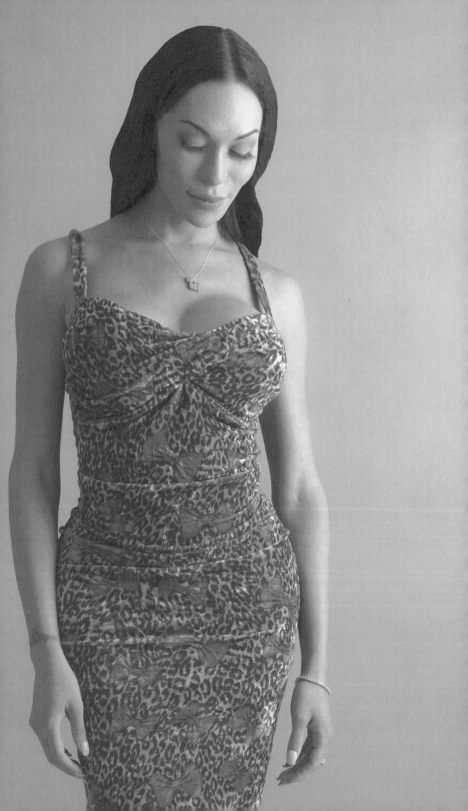

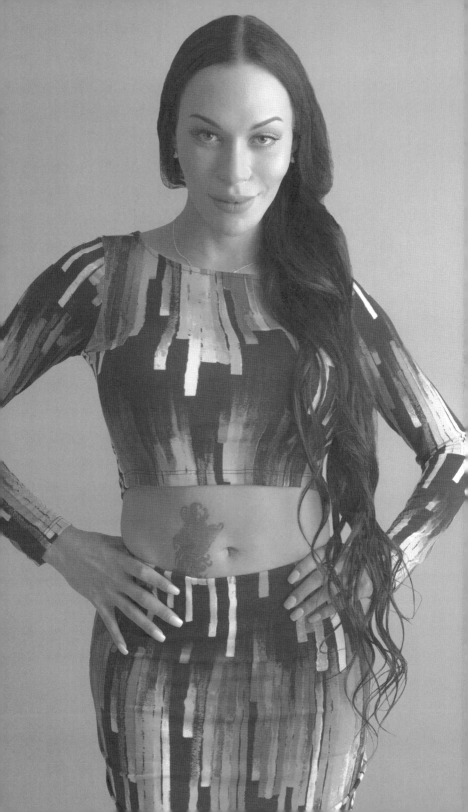

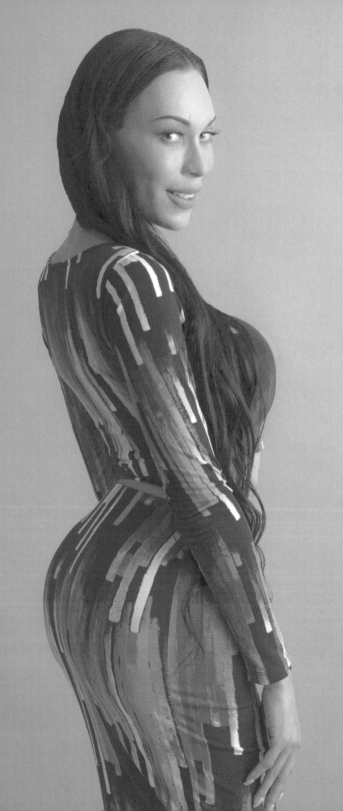

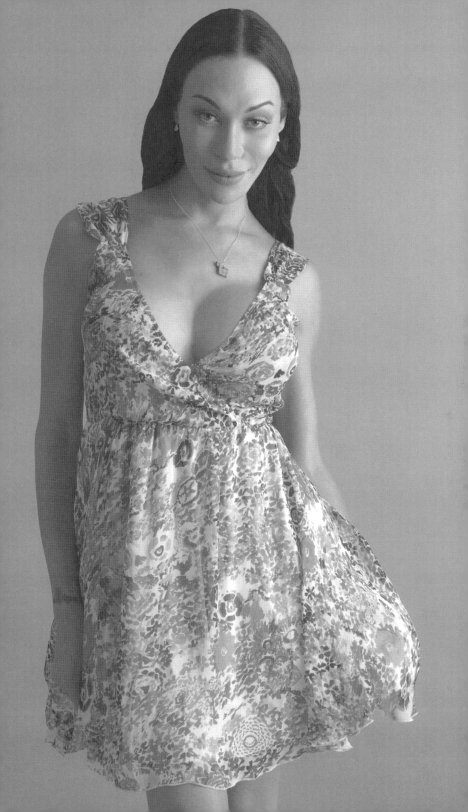

Nameless

Kristel Penn

"DYKE" WAS A TERM I heard frequently in high school; sometimes to my face, sometimes as a not-so-discreet whisper when I passed through the cafeteria. The "k" always sounded particularly sharp, even when the word was hushed, and I spent those four years desperately trying to prevent it from leaving any visible marks.

I didn't think of myself as a "dyke" back then, nor did I know what it meant, but I knew the expected response was to vehemently deny it. It took me years to discern that "dyke" wasn't just a reference to sexuality. At my school it was an umbrella term that was used interchangeably with "fag" and "gay" to describe kids who were effeminate or masculine (depending on their gender), socially awkward, unfashionable, uninterested in sports, and were unable to attain enough social capital to avoid being bullied.

While other girls in my class wore surfer brands like Roxy and Billabong, I wore oversized hand-me-down collared shirts from my dad and had Manic Panic–stained fingers from dyeing my hair *Passion Red* in the bathtub. The competitive

aspect of sports gave me anxiety and I preferred to spend my time at local punk shows than at the beach. I brought gardenias wrapped in paper towels to my teachers that my dad picked each morning from our yard. I was uncool, and sensitive, and artistic, and ill-prepared for the burden of being different. By their definition, I guess I was a "dyke."

Like many closeted LGBT teenagers, my classmates thought it was amusing to speculate about my sexuality. If my enthusiasm for 'NSYNC and Jonathan Taylor Thomas did not mirror theirs, they'd prod for an equally "worthy" crush. I'd often say Lance Bass, just to stop the conversation (oh, the irony), but my insincerity and palpable fear of being discovered as a fraud always gave me away. Female friends thought twice about whether or not I was worth the social suicide and classmates often asked pointed questions in hopes I'd slip up and reveal some "lesbo" secret about myself. Most of my headspace was used to police my own conversations. I was careful about speaking too highly or frequently about same-gender friends, and lived most of my teenage years as a watered-down version of myself.

I grew up in a generation where "gay" meant stupid or reeked of blatant homophobia, and yet it was one of the few labels we could claim for ourselves. Back then, the communal language in Hawaii felt constraining compared to its breadth now. We were forced to share so few terms, regardless if they actually fit, because our language did not yet support the vast scope of our individual identities. Self-identification can help build community, but it also made some of us easy targets in a world that did not yet know how to hold us. For

that reason many of us chose to be labelless; not because we were apathetic, but because it was an issue of safety. When people ask me how I identify, I have to fight the knee-jerk assumption that it's a trick question. And I get it—labels, self-imposed or not, were important in high school. In fact, these verbal membership cards are carried into adulthood with pride by some.

By the time I left Hawaii for college, I was ready to abandon any labels my high school classmates had spent years trying to pin on me, and yet tentatively called myself a dyke when I had to introduce myself at my school's LGBT club. The term didn't feel fitting to me, although neither did terms like "queer" and "genderqueer," which weren't part of my vernacular until I entered college. It wasn't that those terms didn't accurately describe me, but something about the labels themselves felt confining and made me feel unsafe. For most of my young adult life, it seemed easier to be nameless.

I moved to Los Angeles in April of 2010 into a one-bedroom apartment in Studio City, nearly three thousand miles away from my high school bullies. I was labelless and searching for community. At the time, the It Gets Better Project was in its infancy. There were only a handful of videos on YouTube that could be found easily, most featuring celebrities who had experiences I could not relate to. We were only connected by current geography; the thick concrete veins of the 405 were our only commonality.

One gloomy afternoon, on a whim, I sat down and recorded my own video. I shared a story about my high school counselor that only a few people knew. I told the same

story almost fifteen times in a row, until I could get through it without tripping over my words anxiously. It was the most number of times I had shared that experience aloud.

I took a breath, posted it on Facebook, and then turned off my computer for the day. In the weeks that followed, I started receiving messages and emails from friends, people I attended high school with, strangers, and then journalists. Classmates were apologetic for the bullying from *others*, but never owned up to their own participation in it. There were noticeable, even glaring, holes in their narratives. Memory is a funny thing. It's malleable, and I saw how people's guilt molded their experiences of how they treated me into something more easily digestible than the actual truth. Some closed their email confessionals with some clichéd paragraph about always being on my side, supporting me, or some other reassurance my adult self no longer needed. And while I appreciated their intention, I had outgrown my need for their validation.

On most days, I walk through the world with confidence. I go to the women's restroom without fear that someone will stop me and never lower my gaze when I feel someone looking at me. I politely correct sales associates who assume I'm buying something as a gift rather than for myself. On most days my gender identity feels personal, specific, and unnecessary to describe.

But for all the work I've done, some scarring remains. Some days I hide behind my female friends when in line for the restroom, or worse, I will avoid going to the bathroom in public at all. Some days I quickly switch out the words

"partner" for "friend" depending on the context of the situation and who I'm talking to. Some days I fixate on a brief interaction when a stranger does not know how to address me and decides to use all of the pronouns they know. Some days I wonder if being less binary makes me less lovable to those around me.

I know now that neither experience has the power to erase the other, and honestly I don't need it to. I can hold within me that the ability to stand unapologetically tall comes from overcoming the fear of being backed into a corner. I can use labels when they fit, when they make sense, and when I feel safe, and know I am exactly who I am without them.

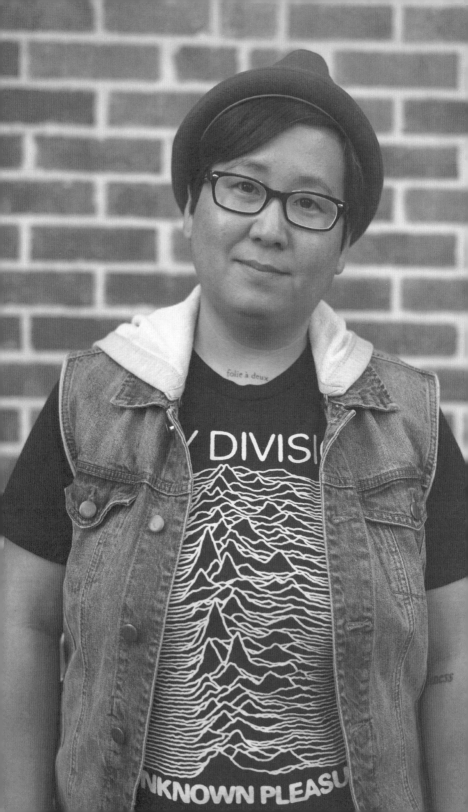

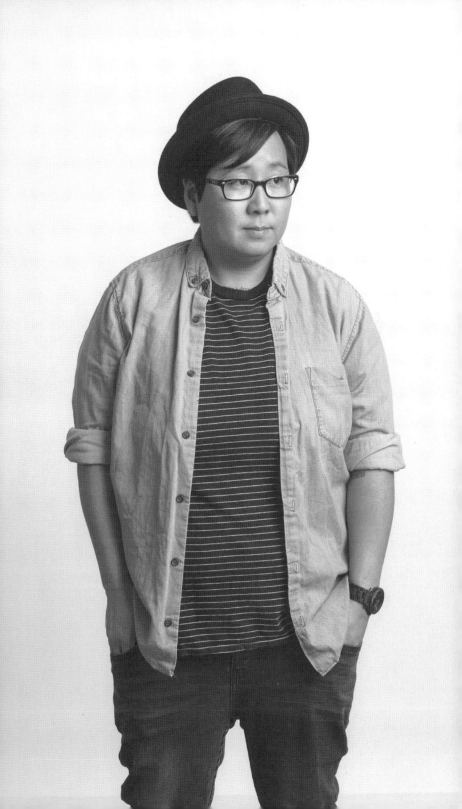

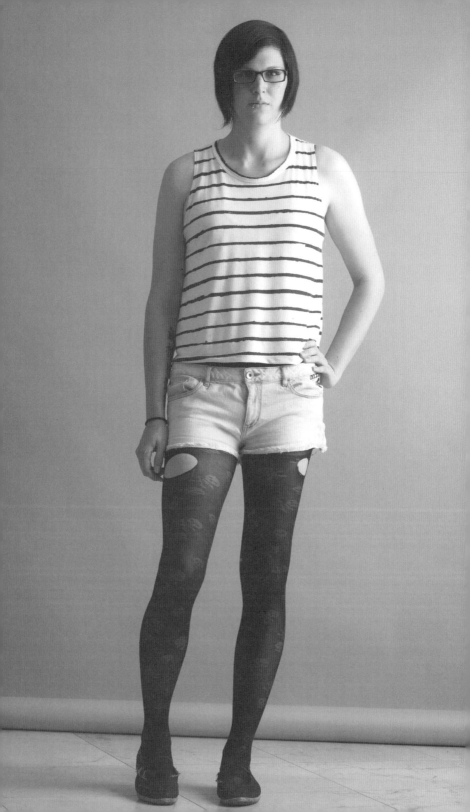

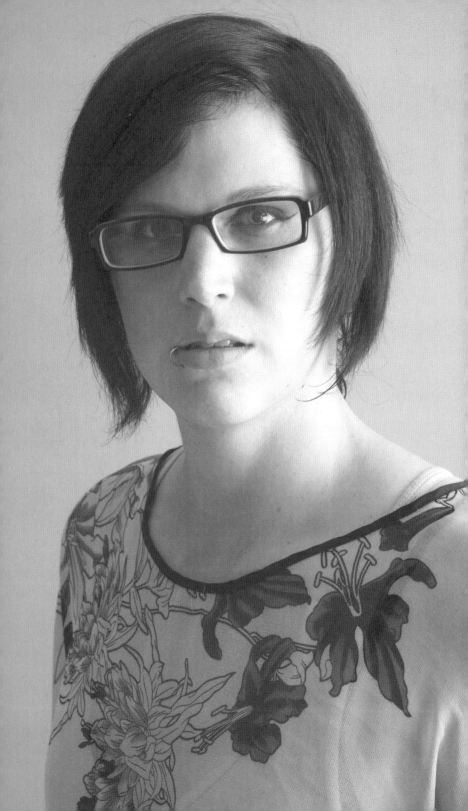

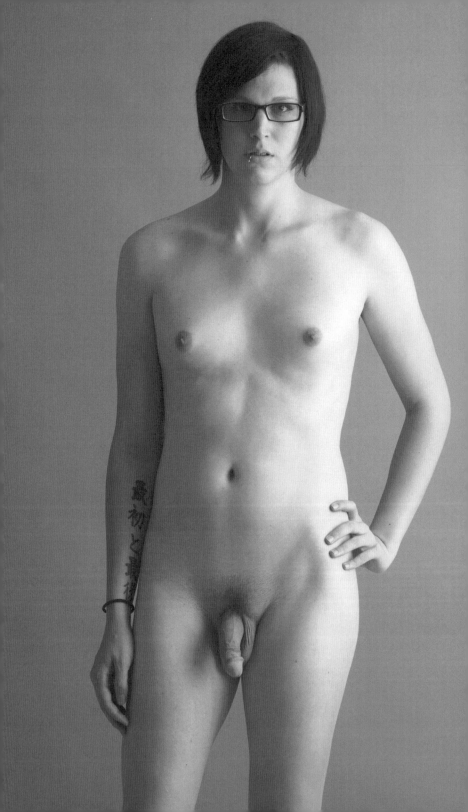

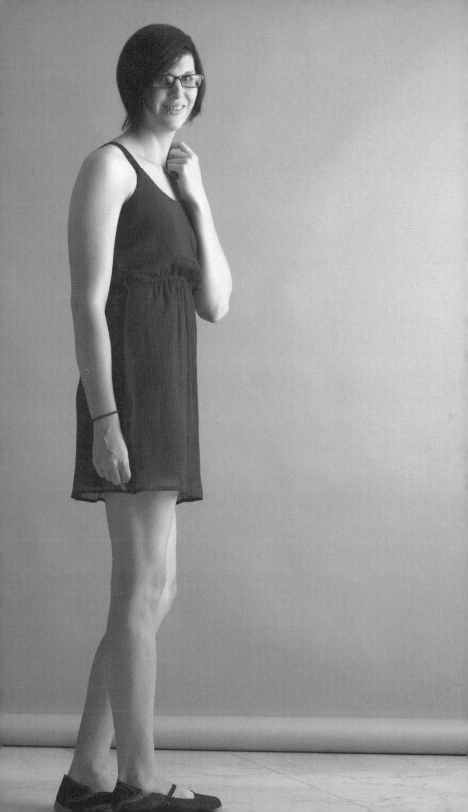

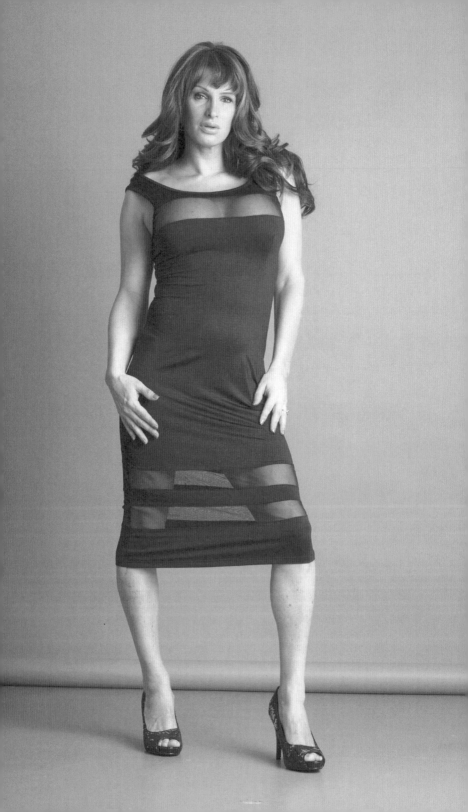

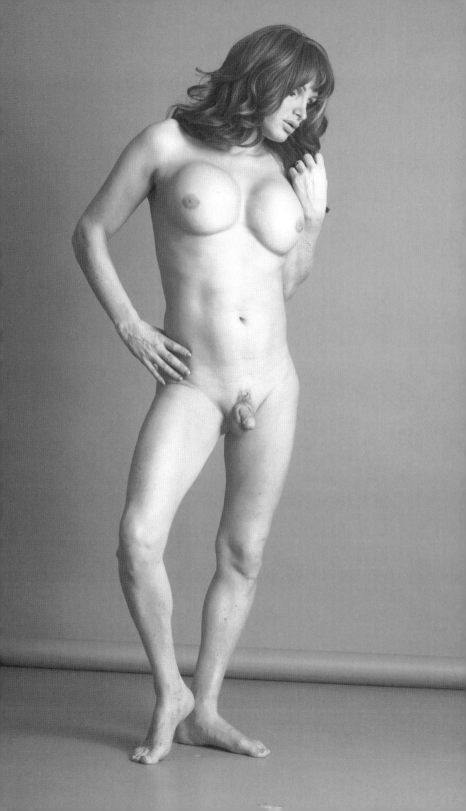

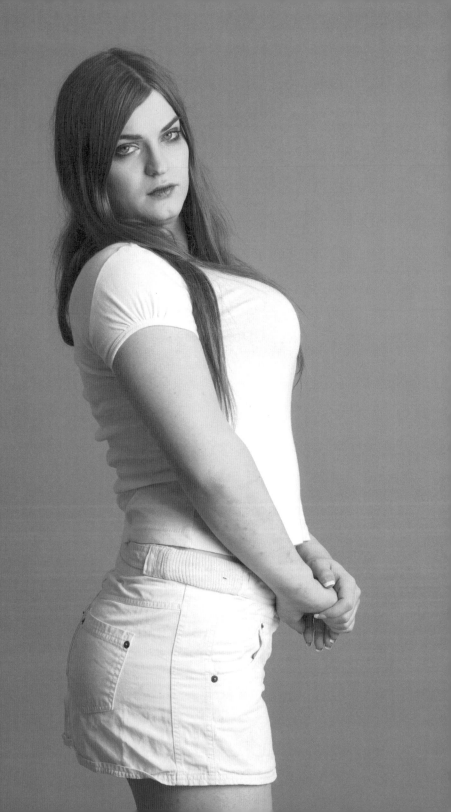

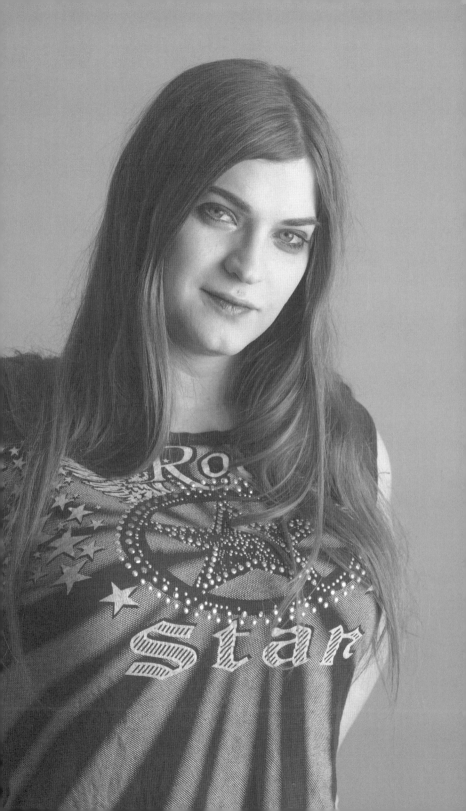

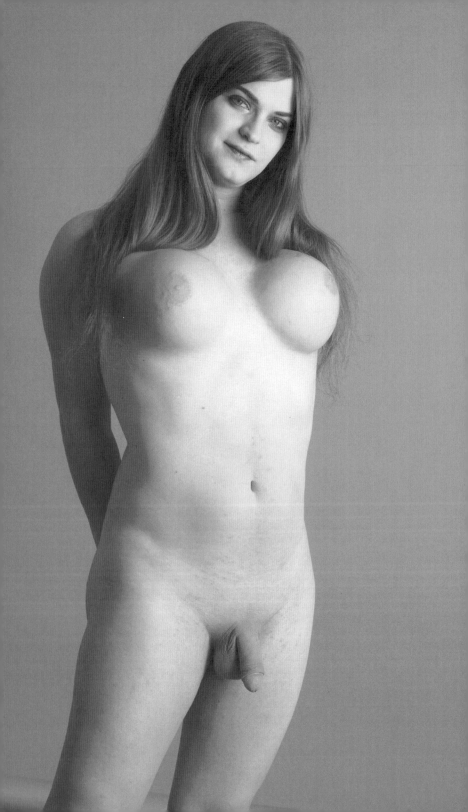

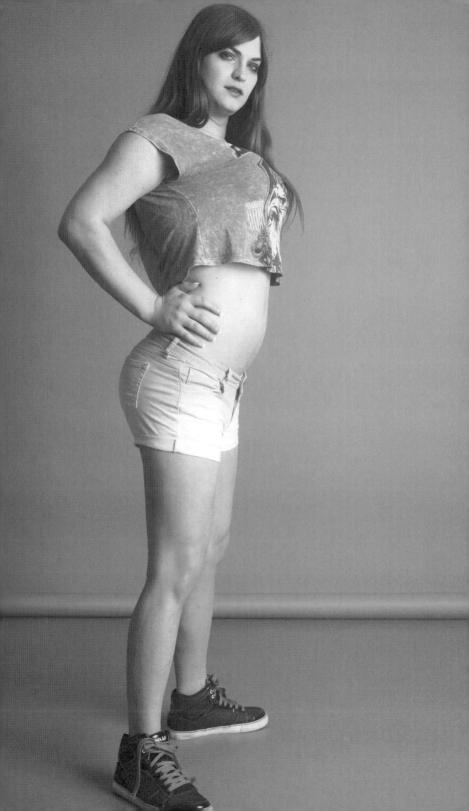

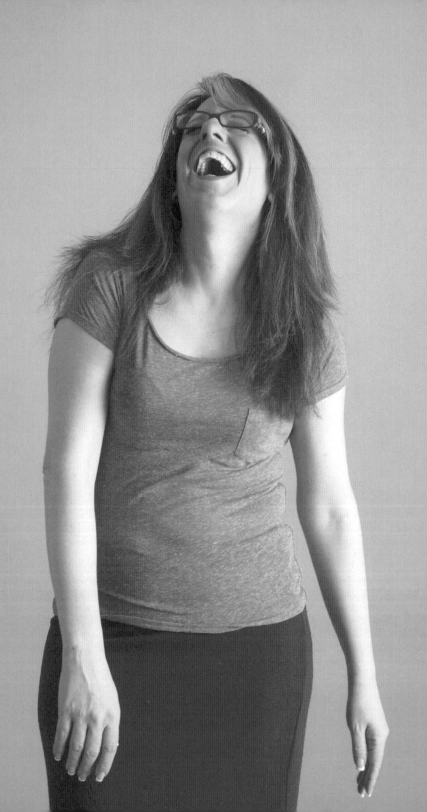

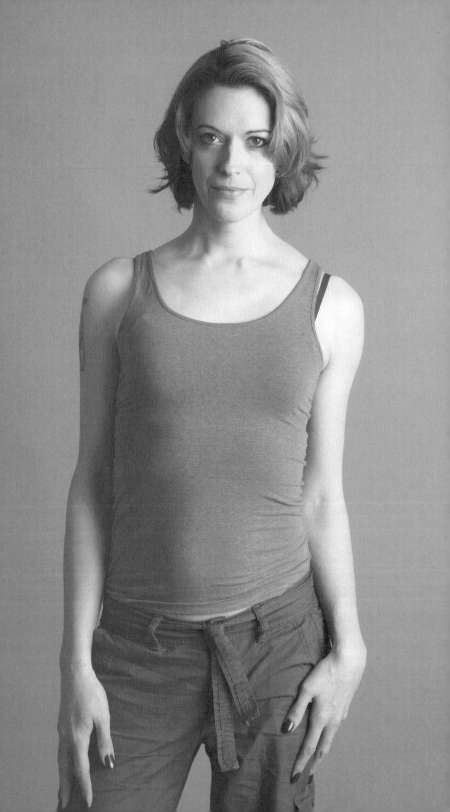

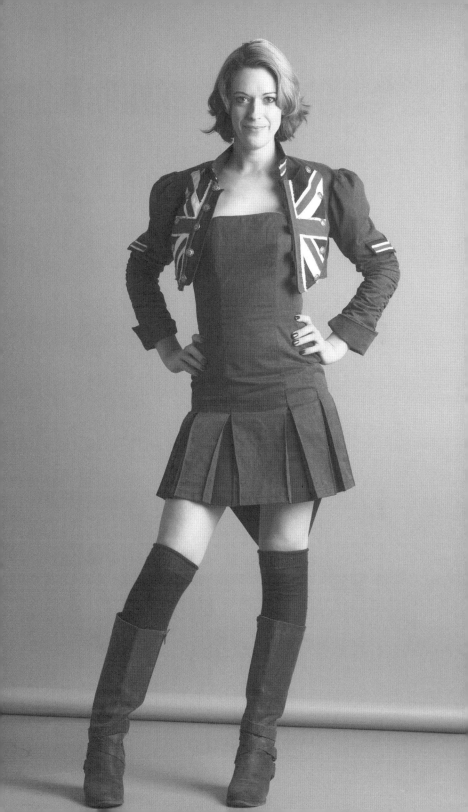

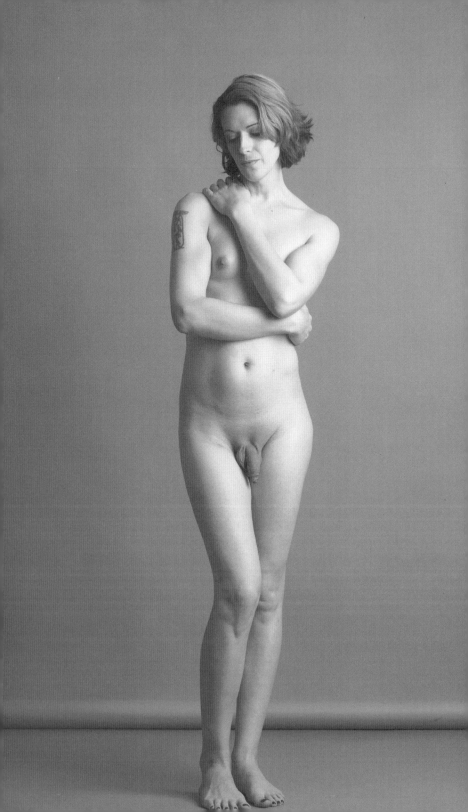

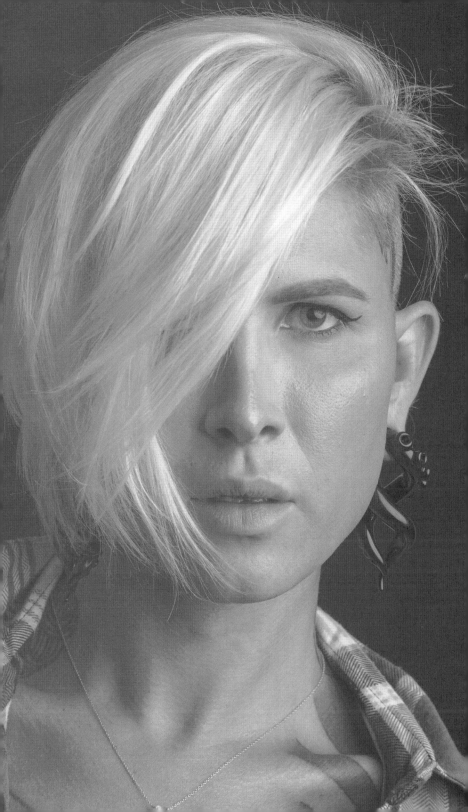

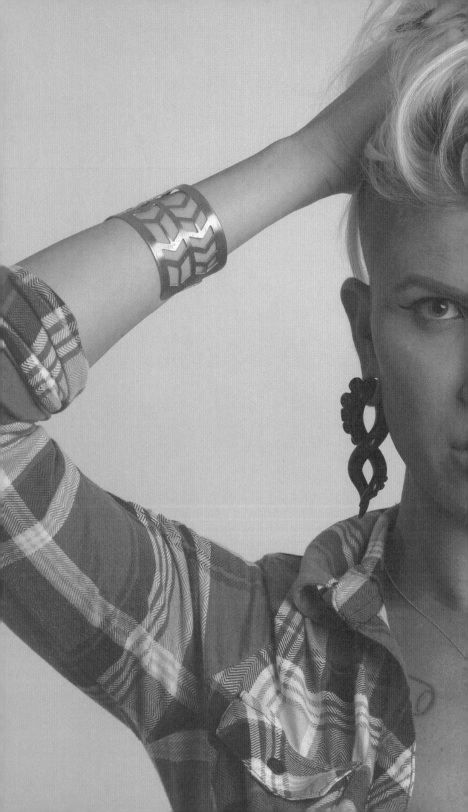

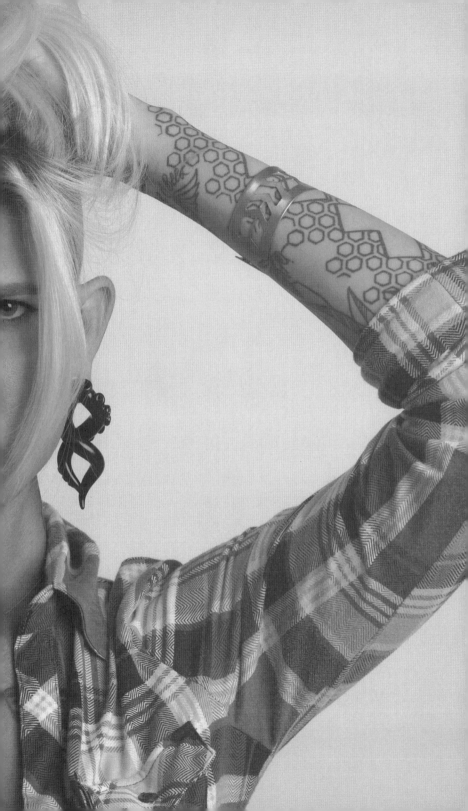

MIRROR

Kwesi

OPAQUE SOLITUDE
Quietly restrained
Chains knocking at my door
So sorry for YOU
YOUR VISION FUZZY!?!
That's what you THINK you see;
Mirror magnification...
Paper thin,
Seen through.
Holy screen of fear
THAT'S YOU!
(Not me)

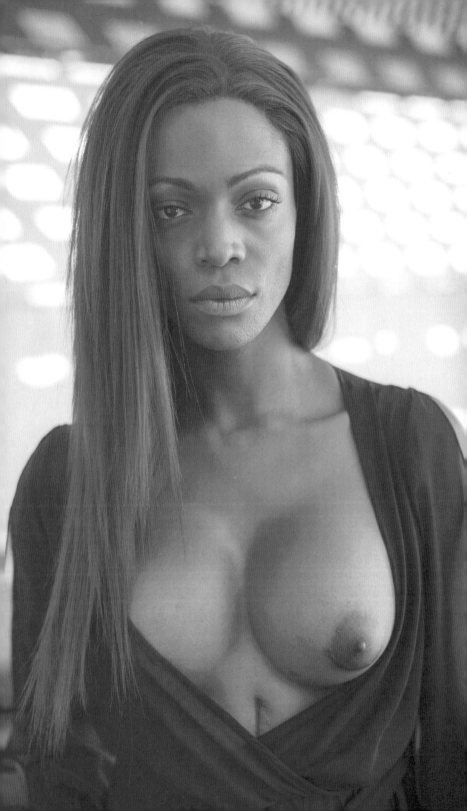

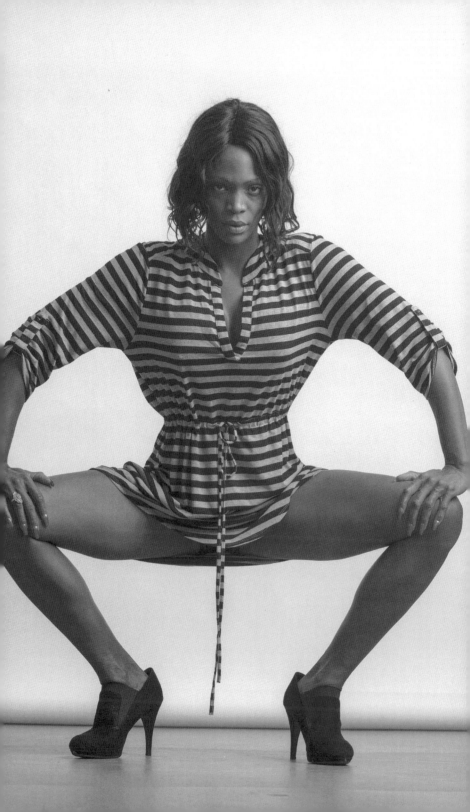

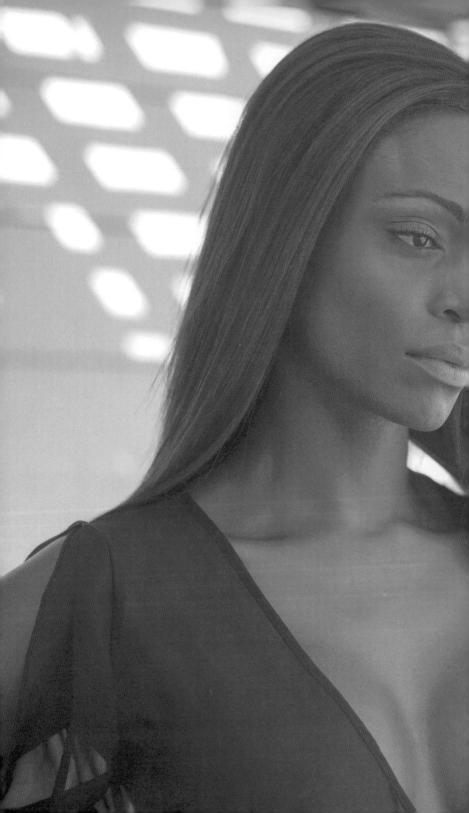

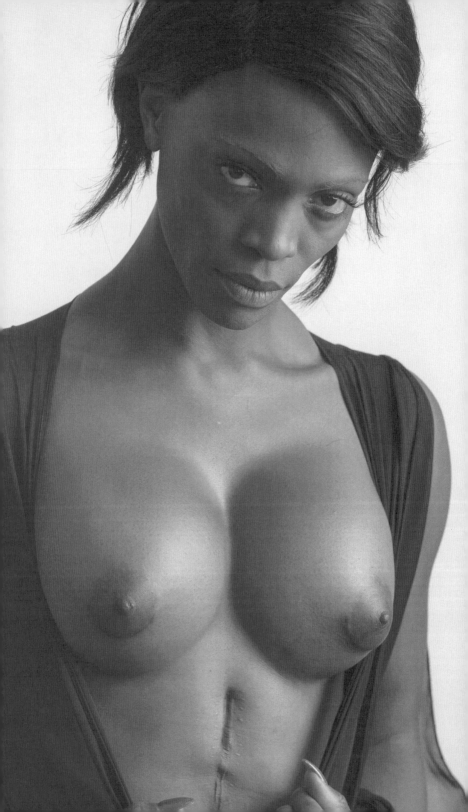

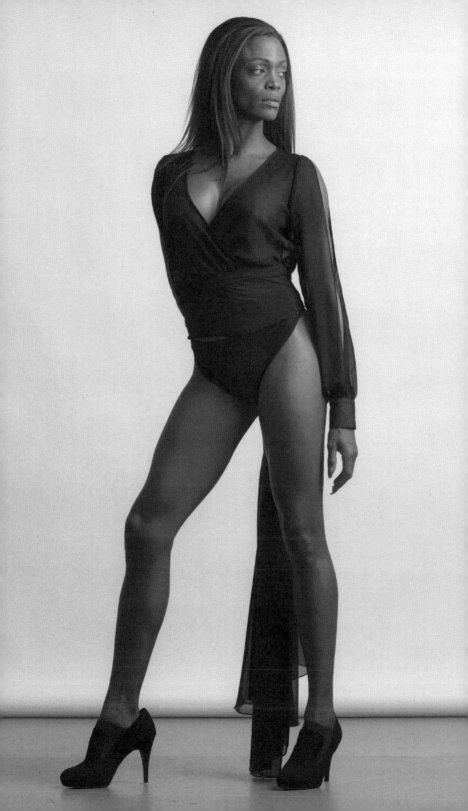

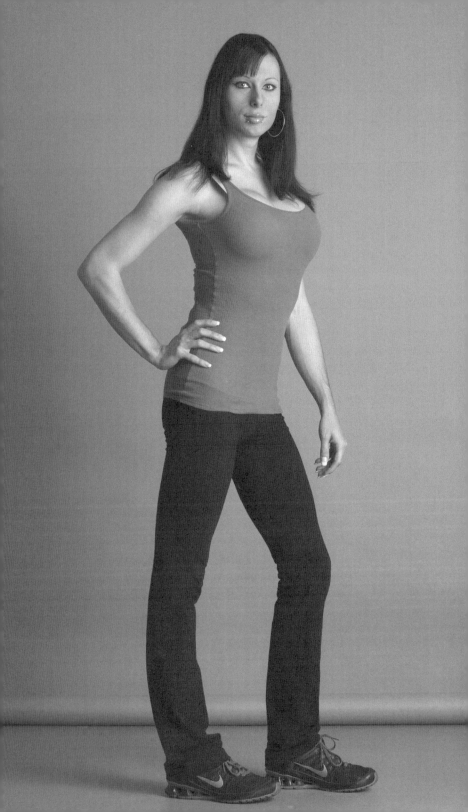

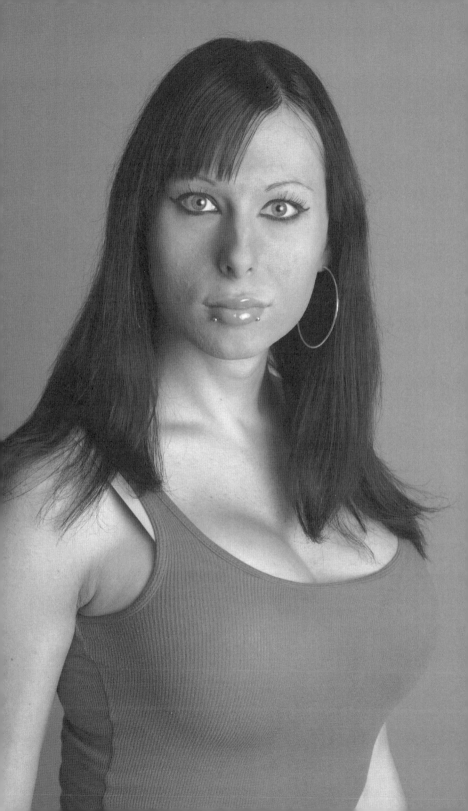

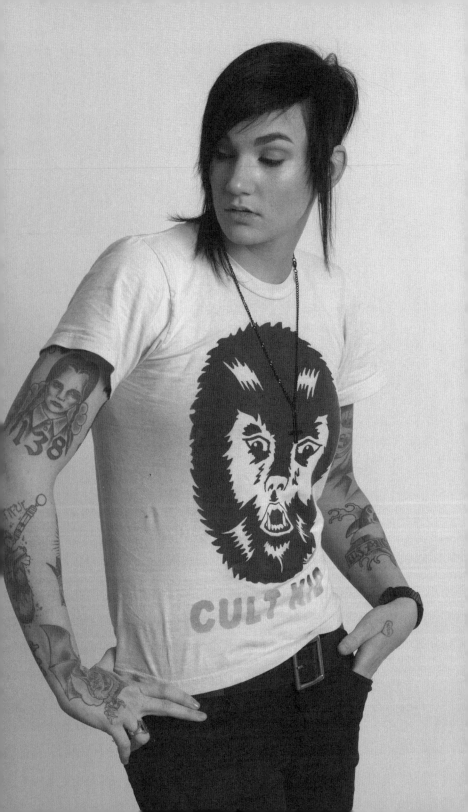

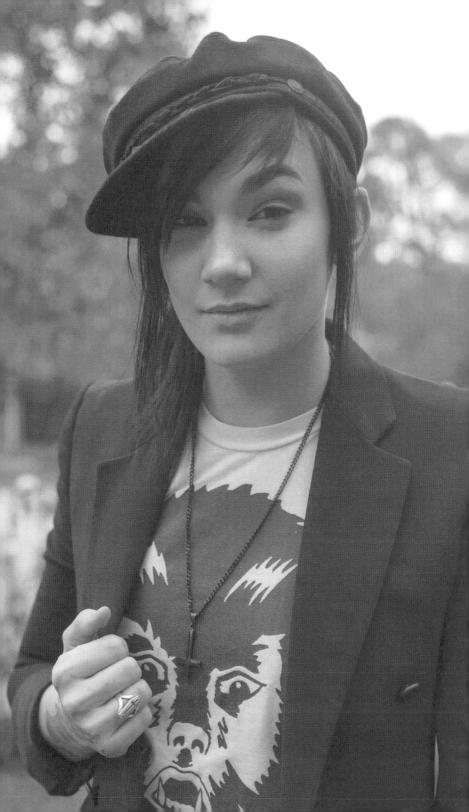

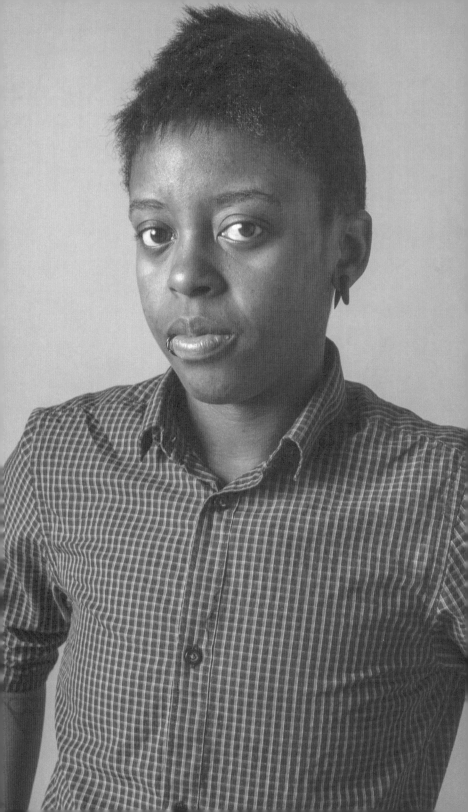

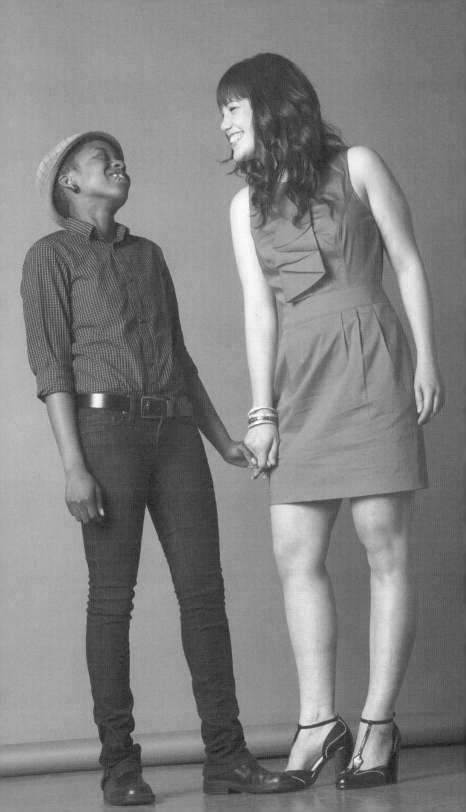

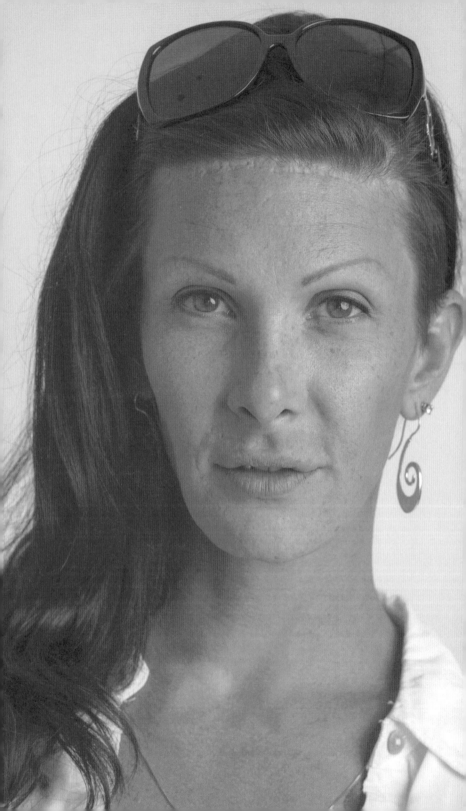

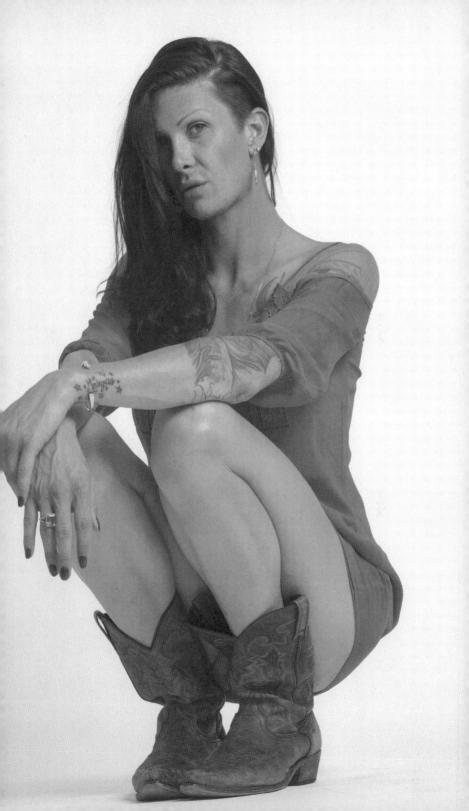

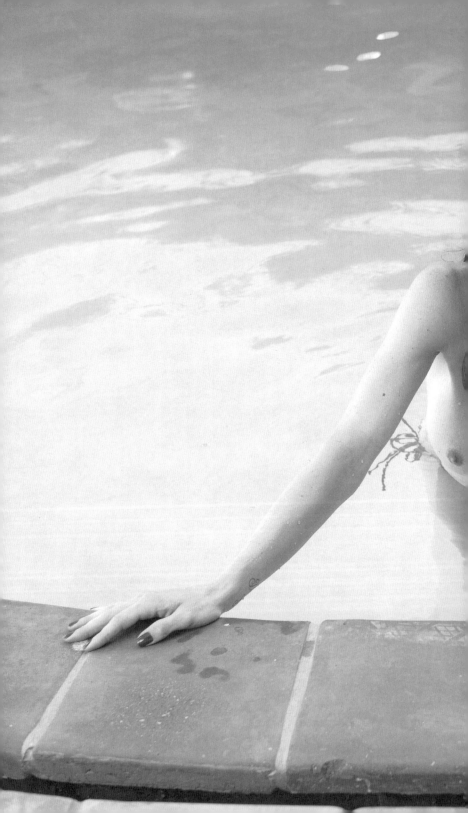

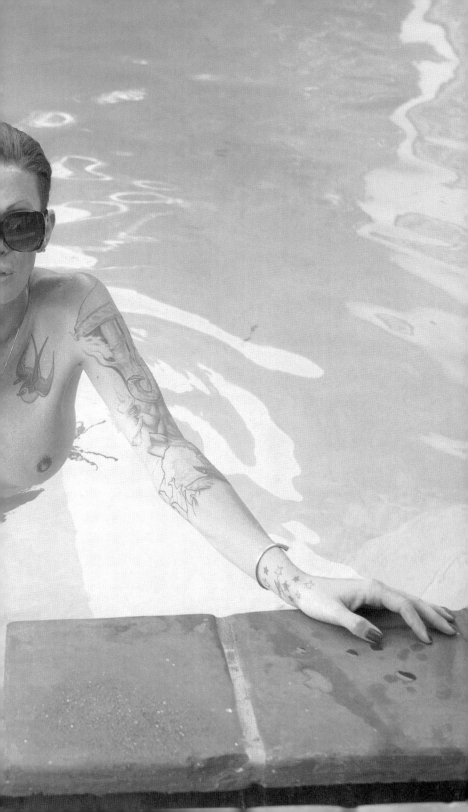

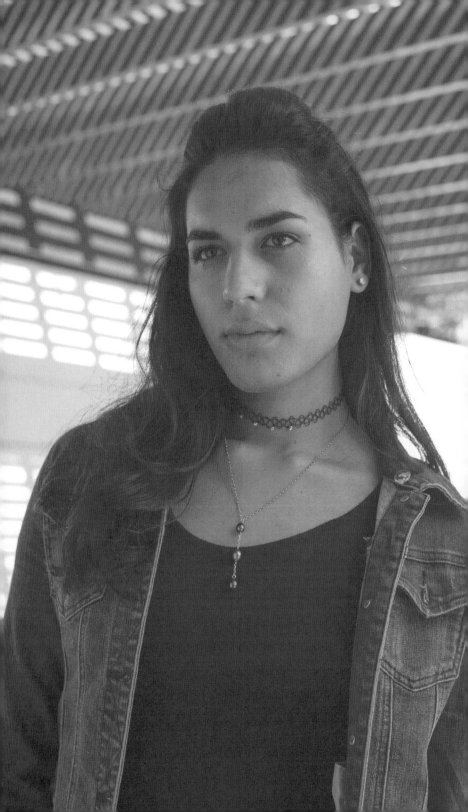

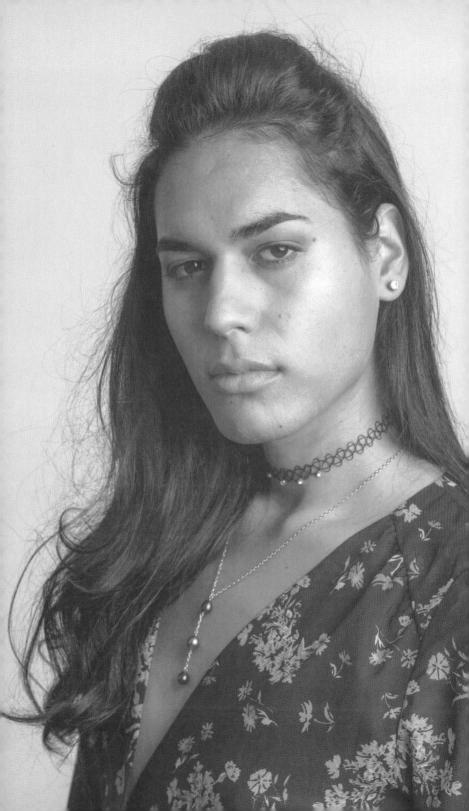

Loving A Trans Person
By Michelle Austin

W ITH THE RISE OF trans issues, and the trans movement, I have had people approach me about how to love someone in their life that is trans. Loving a trans person comes with understanding and acceptance. It may be your friend, family member, or a lover. A lot of times it is the cisgender people that have the hardest time understanding or accepting trans people. Hopefully, through this article I can help you in loving the trans person in your life.

I have spent many years of my life trying to be loved and find love. I think love can be a hard thing for many trans people. We fear never being loved, let alone being accepted. One of the hardest parts of my transition was the fear of not being loved; I delayed by transition for a few years out of that fear. I come from a big family and to be rejected and not loved anymore by them taunted me for the longest time. I was two years into my transition before I even told anyone in my family. That fear in me rose again: what would happen if my family never wanted me around anymore? That fear scared the shit out of me, and that same fear scares so many trans people. Some people worry about losing the acceptance

and love of their family. That is the biggest struggle: we don't want the people we love to look down on us, or even reject us. The reason so many families reject their trans children has a lot to do with religion. I was blessed that I had a family that somewhat accepted me before I told them I was trans. At the age of fifteen I had come out as being gay because that's what I thought I identified as. It took them time but they understood and came around. The church I grew up in was a major help in helping my family with that, so when I came out as being trans they were right there again to help my family with their understanding of what that meant for me and God. Now, even though my family is religious, I am not, but to this day they still worry about where I will go one day after leaving this earth. That is the issue with so many families, they are too focused on what will happen to us when we are gone. What we all need to be focusing on is what is going on right now, in the present. It really is how to be there for our loved ones.

Trans people struggle with loving themselves because they don't see who they feel like when they look in the mirror, and it's sometimes hard to change. Not every trans person has the luxury of getting on hormones, visiting doctors, or changing their body instantly. That cannot be good for trans people, so they need ones to love them and help them through the journey. They need support and love. When a person identifies to you as being trans, it may take them months or even years to get to become their authentic self. That journey can be hard and painful, the point (for you) is to love and help them through that journey with love. If more trans people

just had love, we would not see so many suicides within the trans community.

As a friend, family member, or lover, the best thing you can do is to be there for them, as you would be for any other person you love. Respect the gender they feel they are, even if their outer appearance has not yet got to that point. Try to understand their struggle, try to put yourself in their shoes. I know it is not easy because you have never felt like you were in the wrong gender, so it can be hard to comprehend. Just support them and try the best you can to show them that you can and do love them. I think it is safe to say that love and compassion can go a long way with a trans person. Respect their journey and respect their true authentic self, even if they have not gotten there yet.

One of the biggest misunderstandings is that gender identity and sexuality are two different things, so you can't assume when someone chooses to change their identity it means their sexuality goes with it. The best thing you can do in the process of loving and understanding a trans person is ask questions and learn as much as you can. Every trans person has a different story and a different feeling. You need to help find out what the person you love's story is. For some trans people, it is cut and dry, for others it can be complicated, and you have to let them tell you their story. Not every trans person identifies as the opposite gender, sometimes they don't identify as any gender, that in itself is something you and your loved one need to explore and you need to try to understand. Never assume anything with a trans person. If you have

known one trans person, the next one will not be the same. You have to get to know each person's individual journey.

The trans world is like a rainbow; there are so many colors and different layers to each individual person. There are so many different stories, outlooks, and life experiences we all must know. Each trans person identifies differently, and as more stories come to light and more trans people are seen in the public eye, we will start to see those identities come to life. The biggest thing to remember is, we are all human and we all bleed the same. We all have a heart and a soul that is yearning to be loved and accepted. That doesn't change with trans people; we are all the same with lots of different layers. Your job is to try to understand and accept the ones you love as their authentic selves.

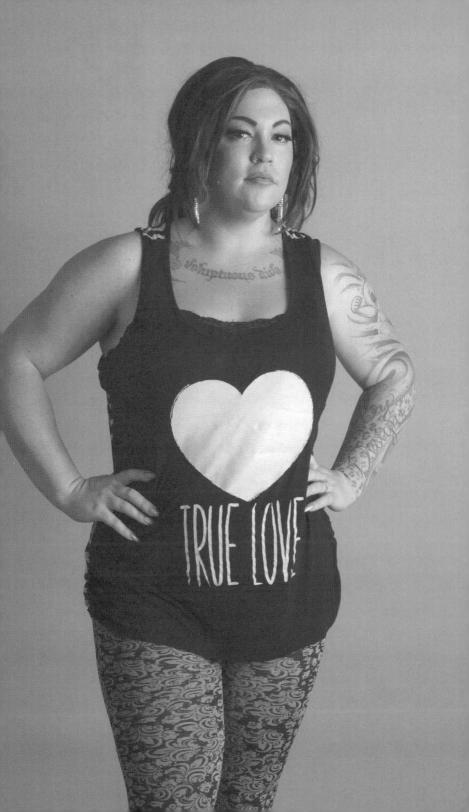

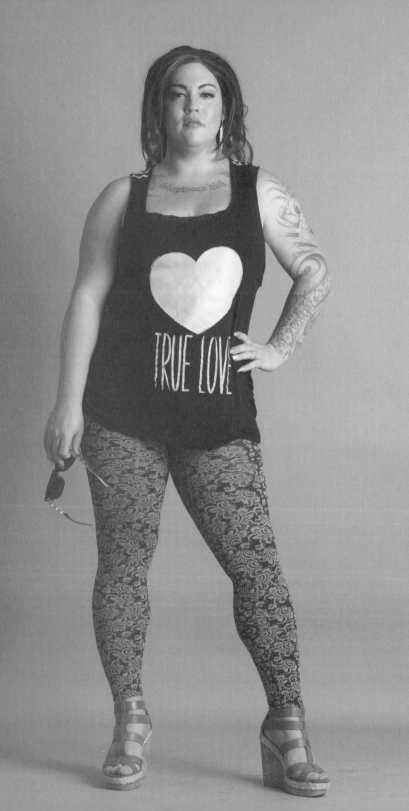

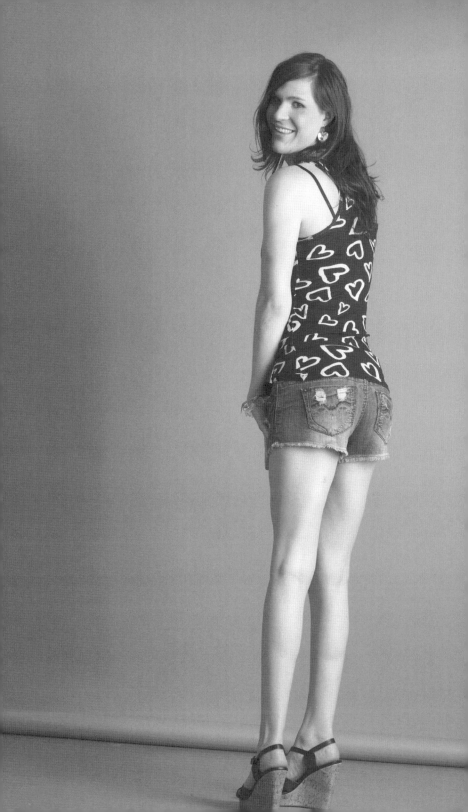

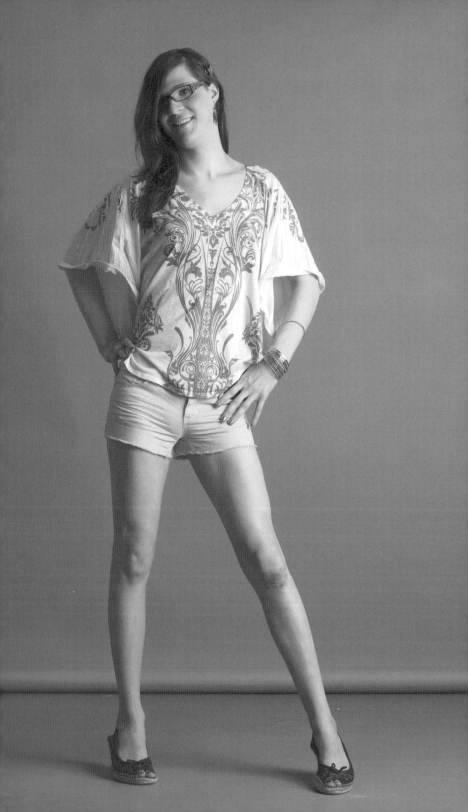

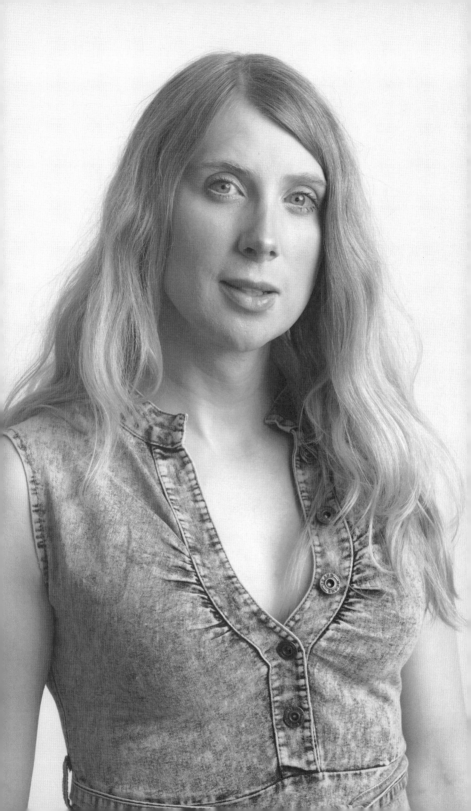

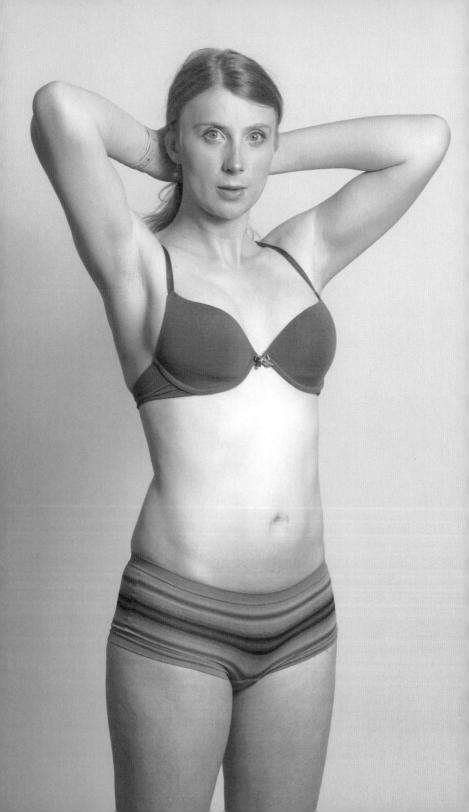

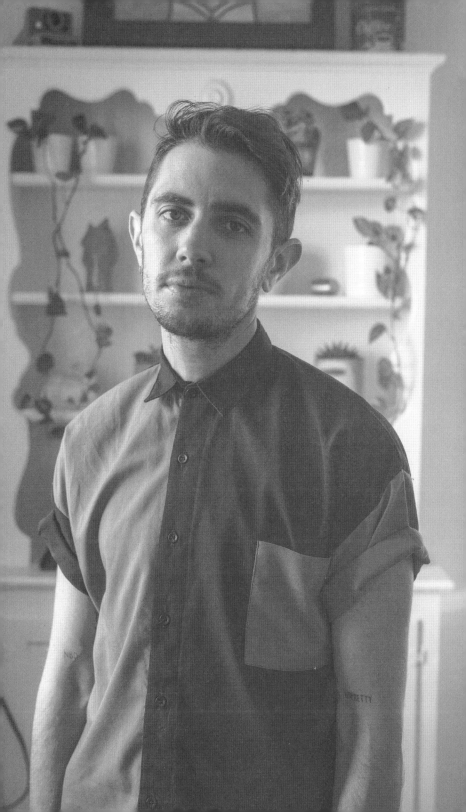

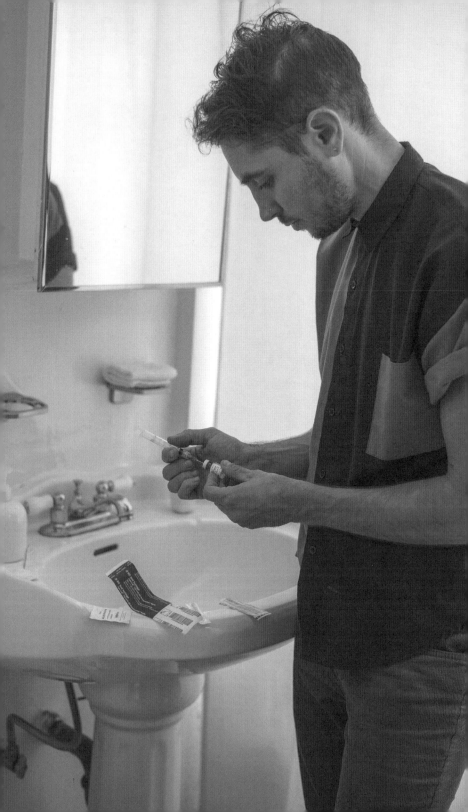

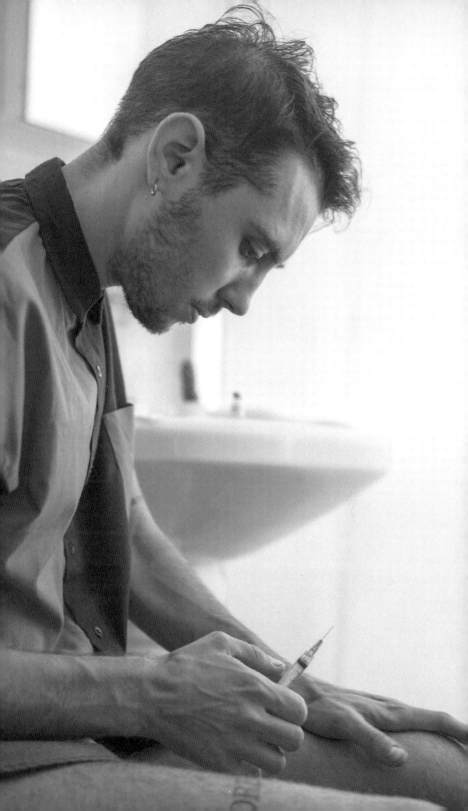

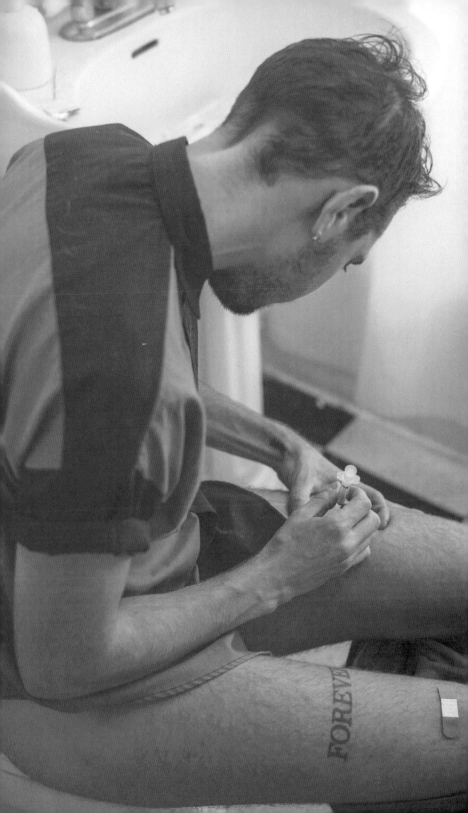

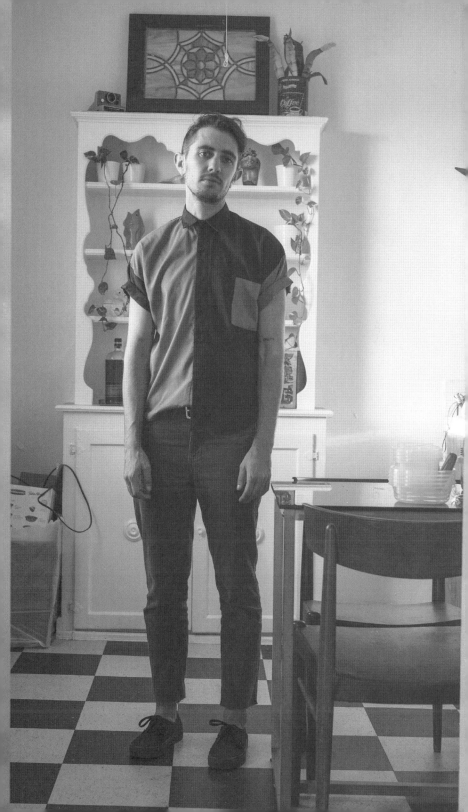

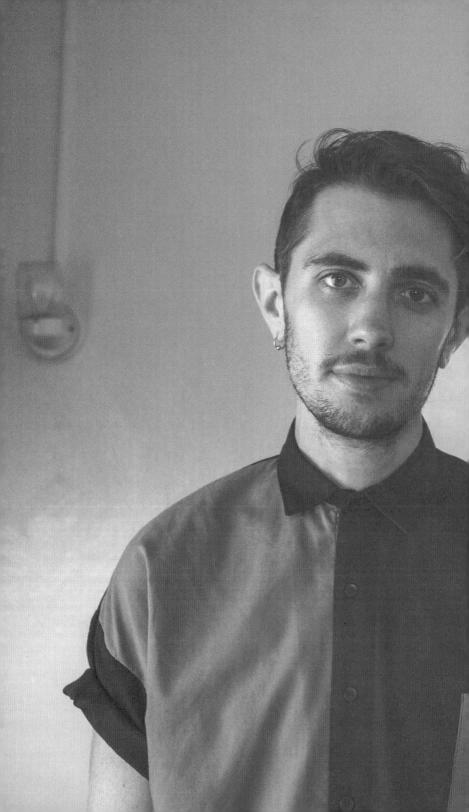

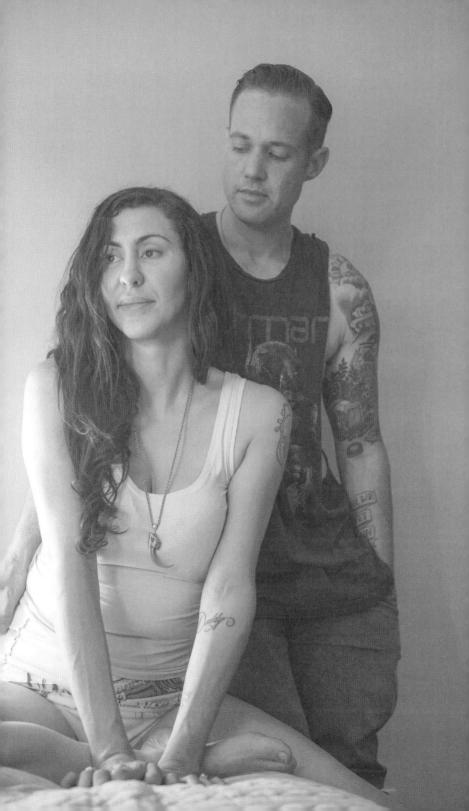

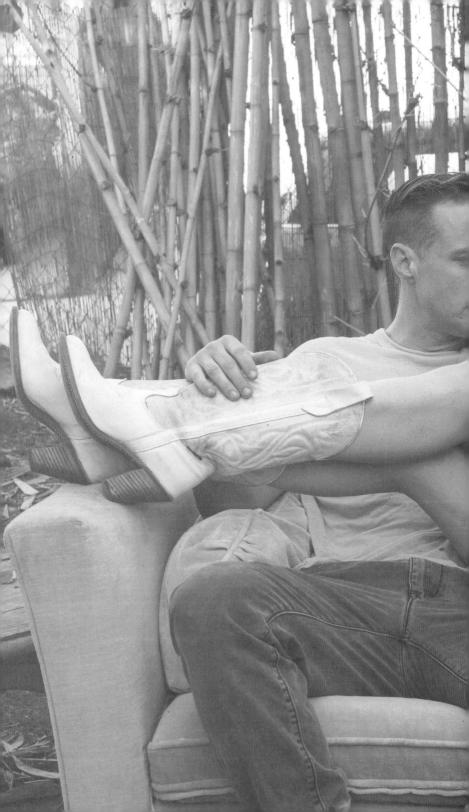

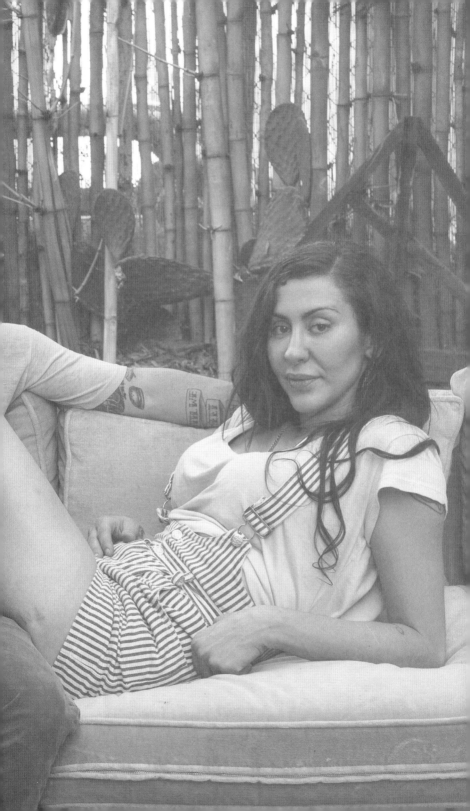

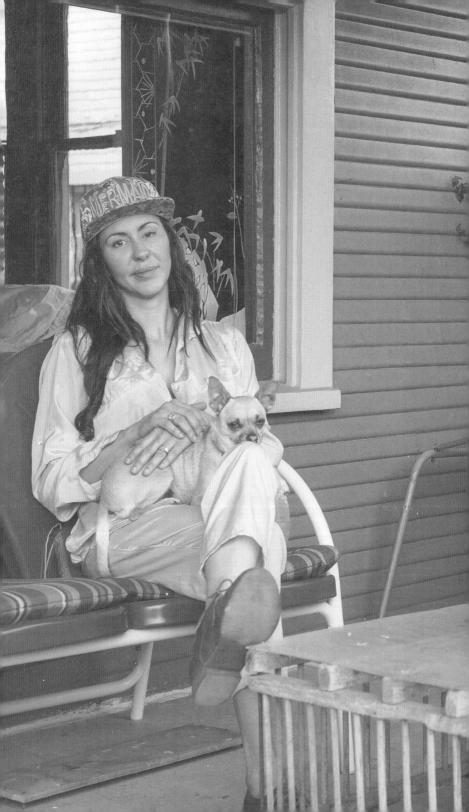

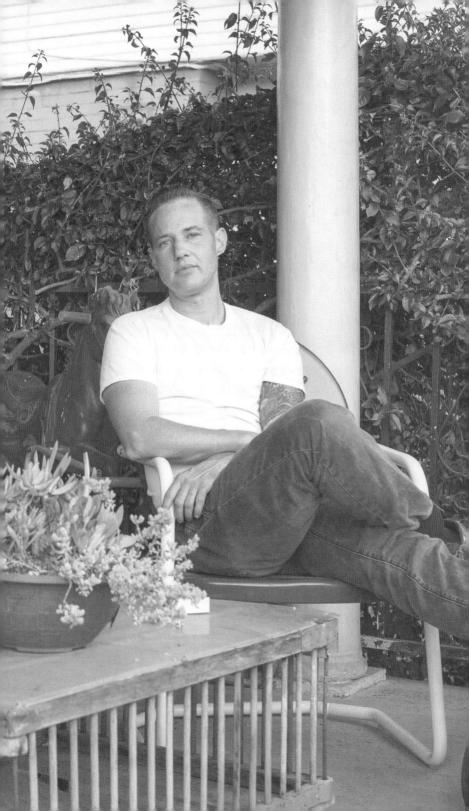

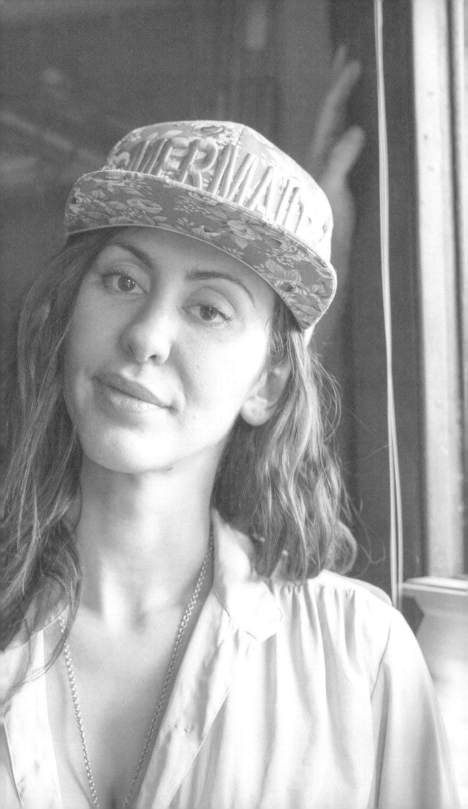

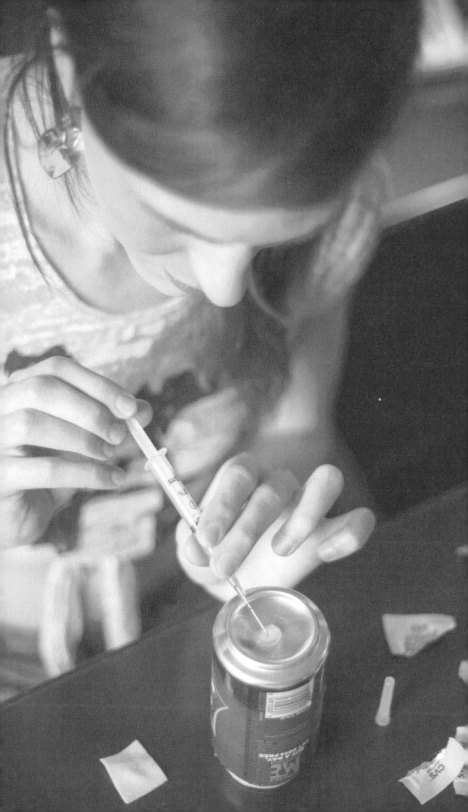

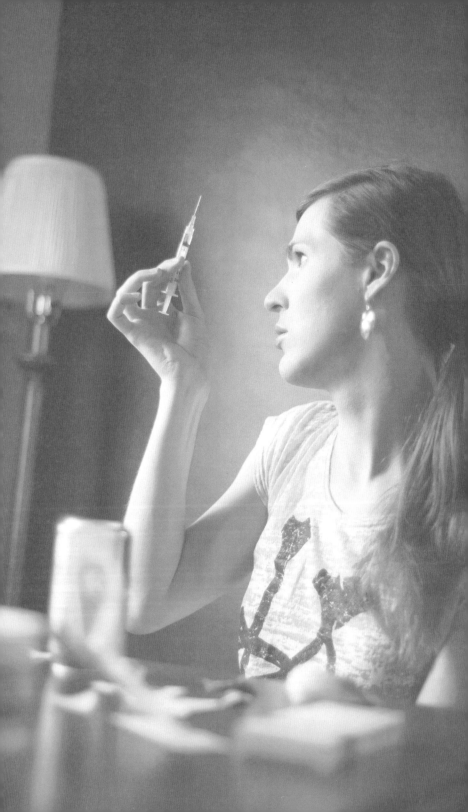

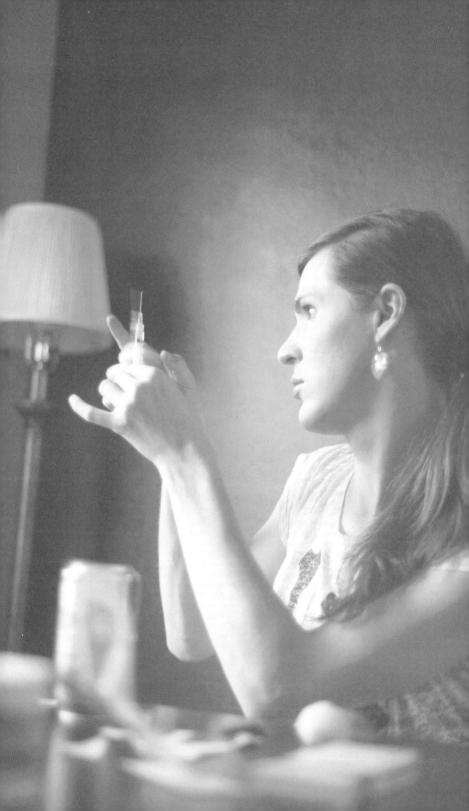

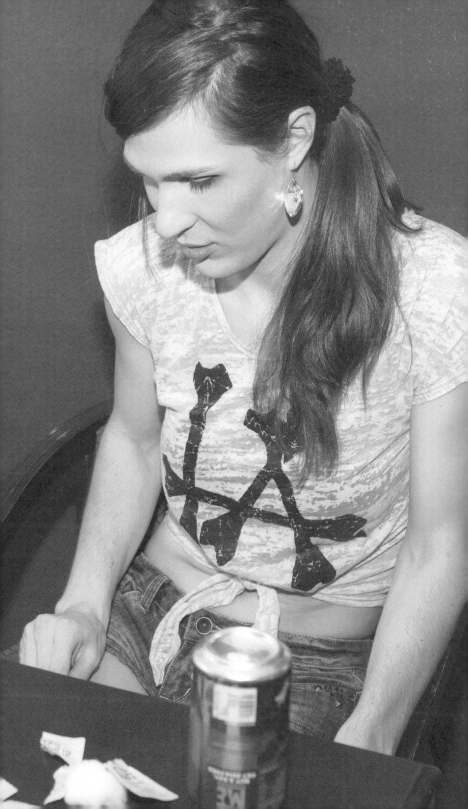

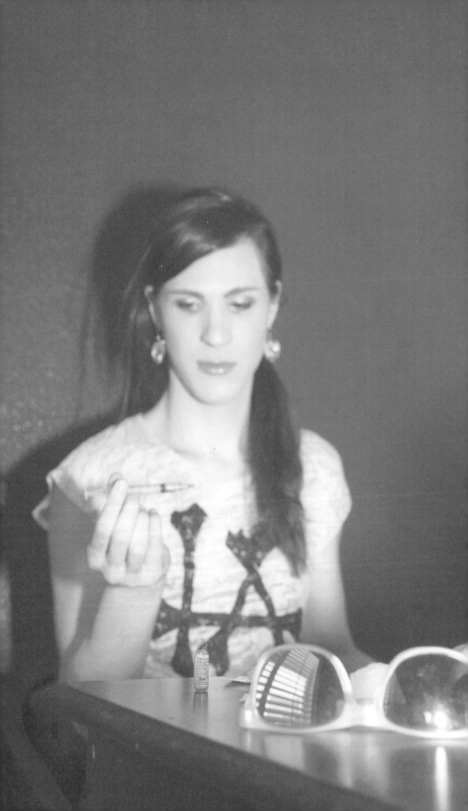

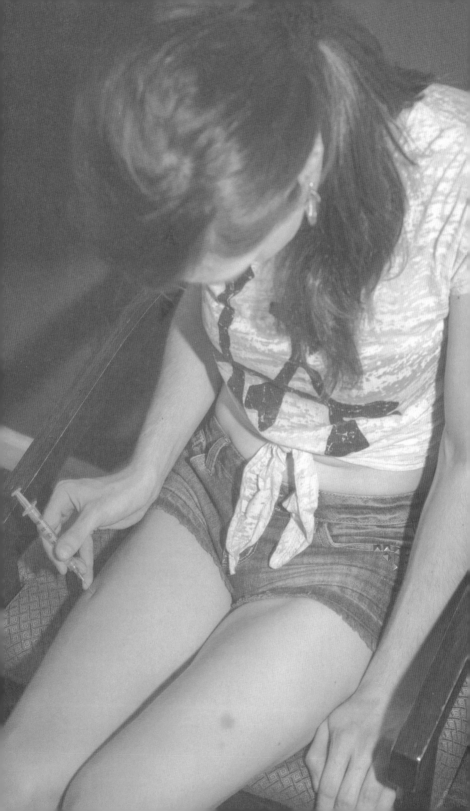

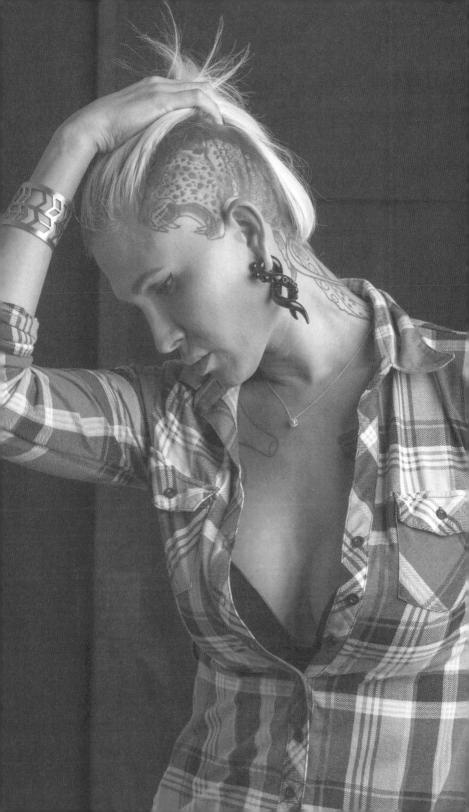

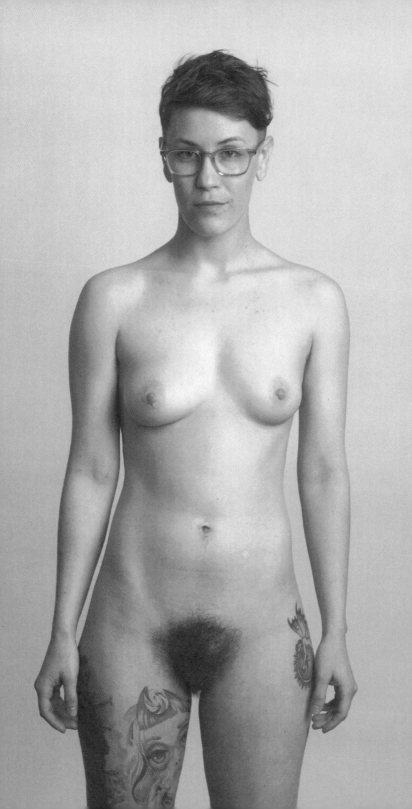

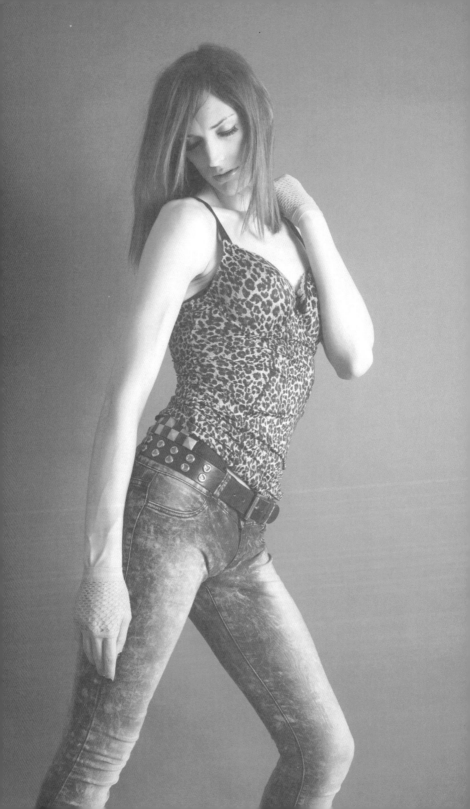

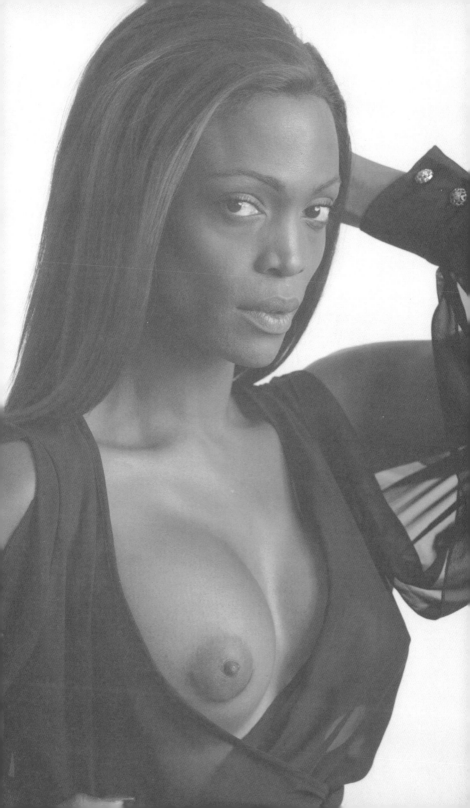

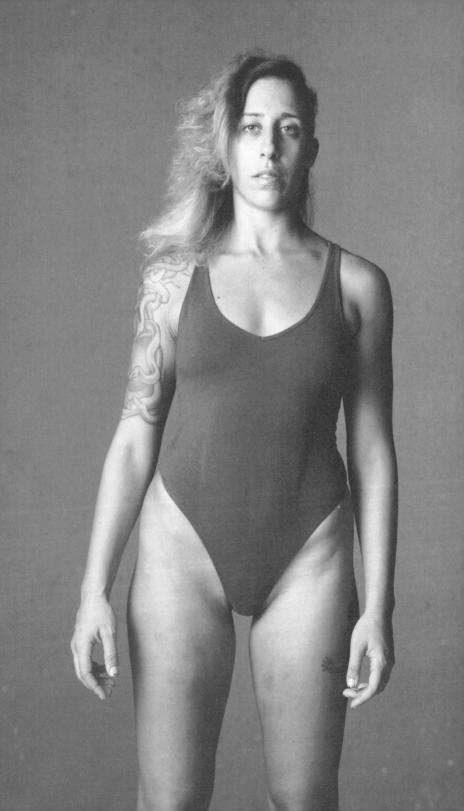

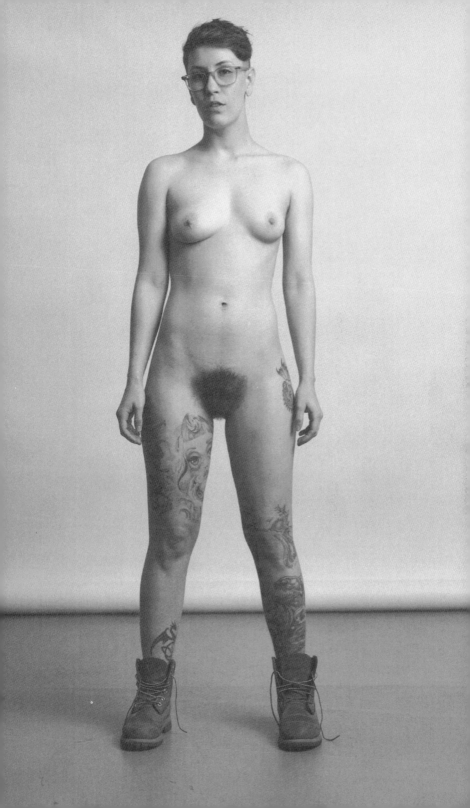

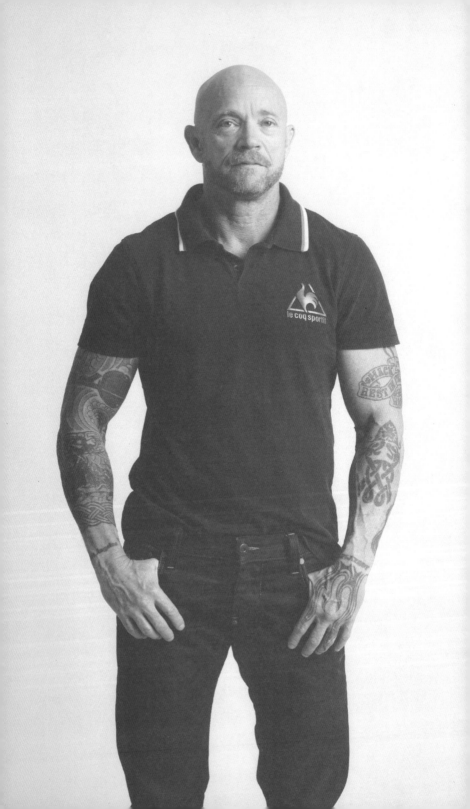

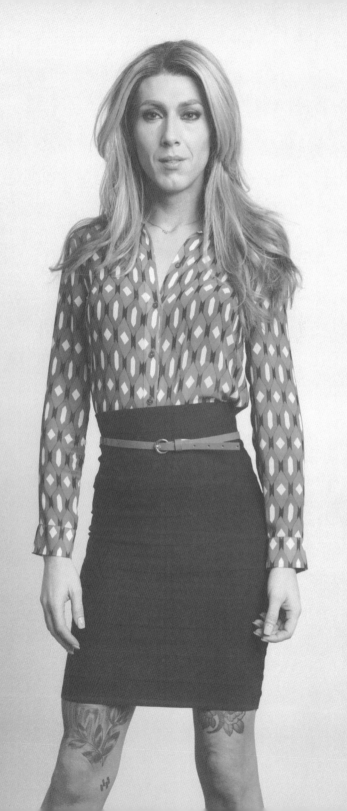

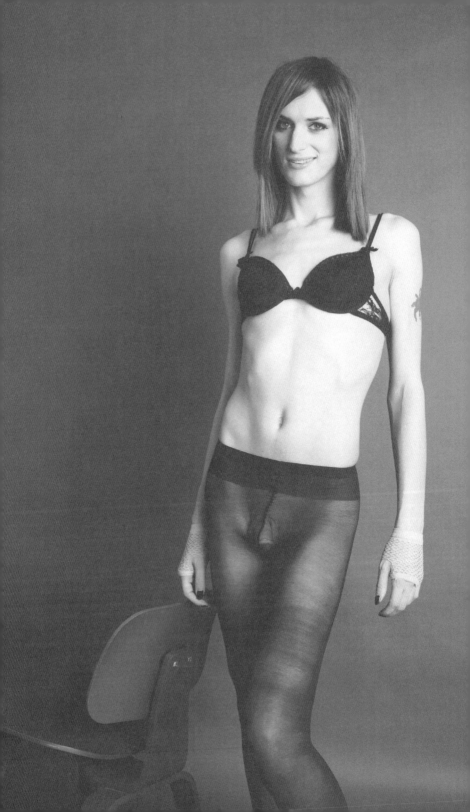

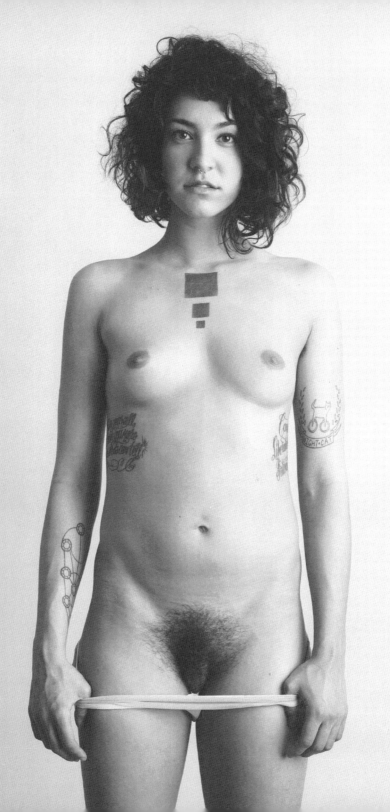

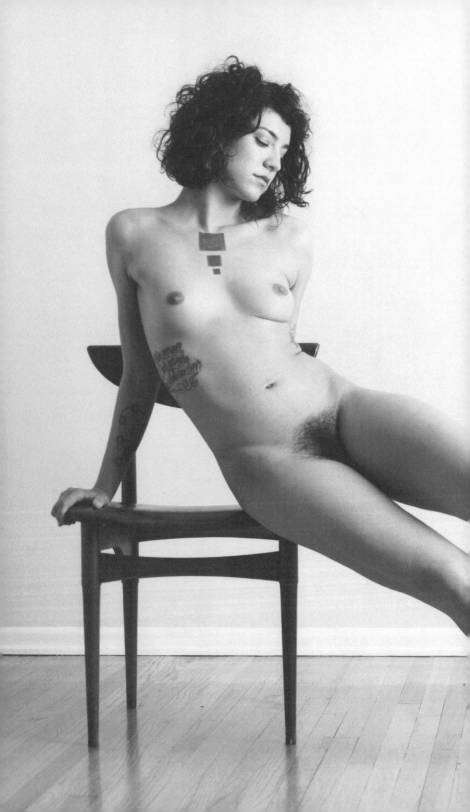

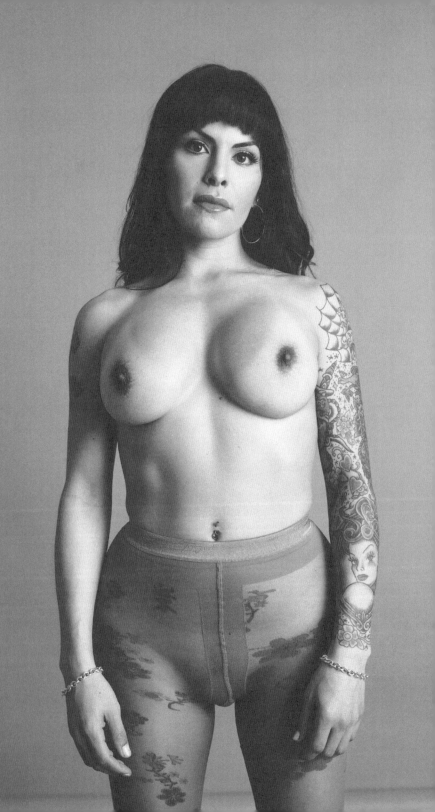

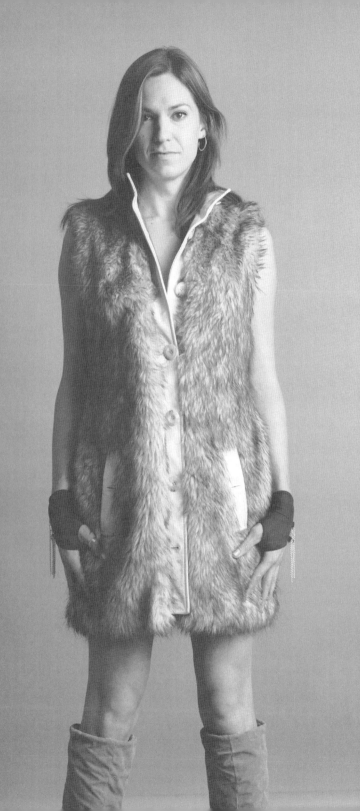

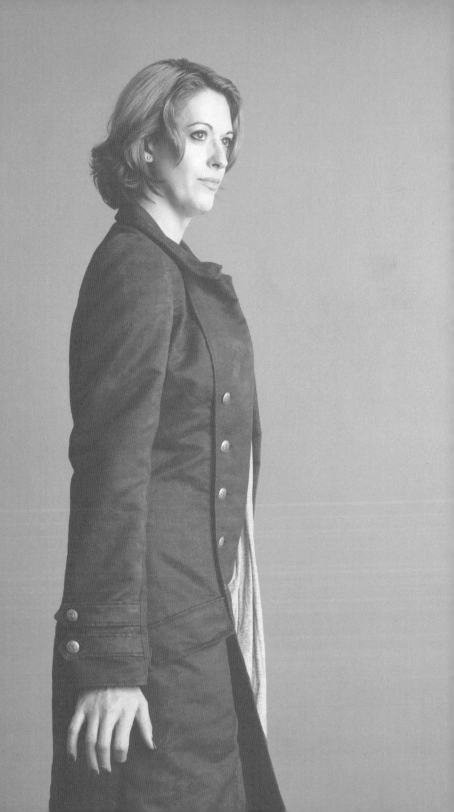

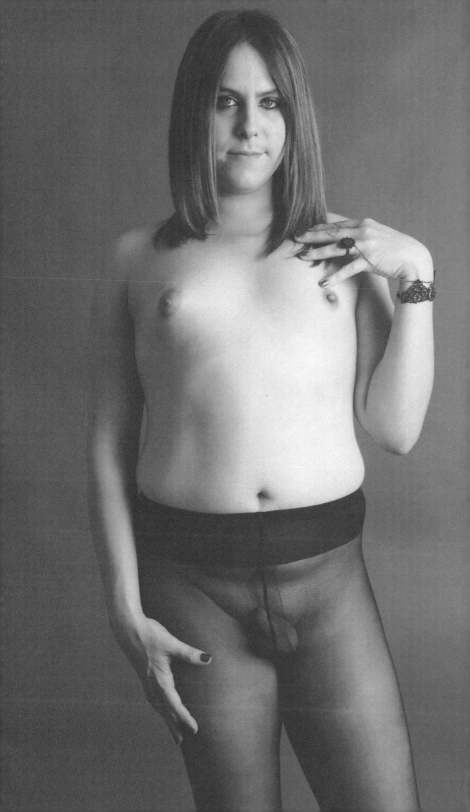

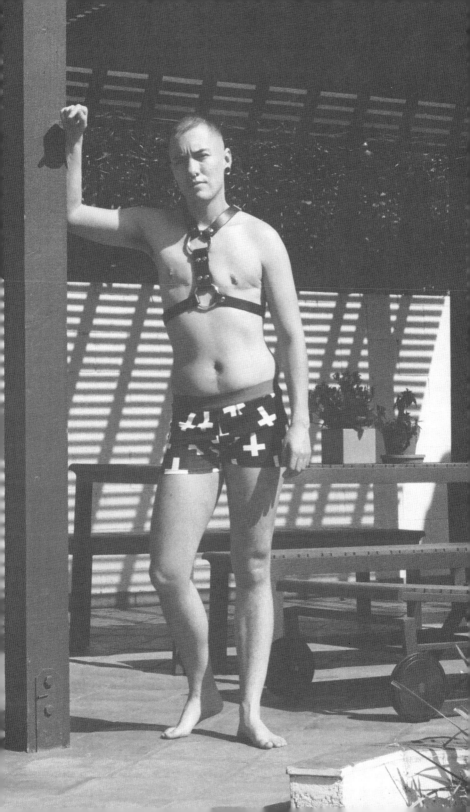

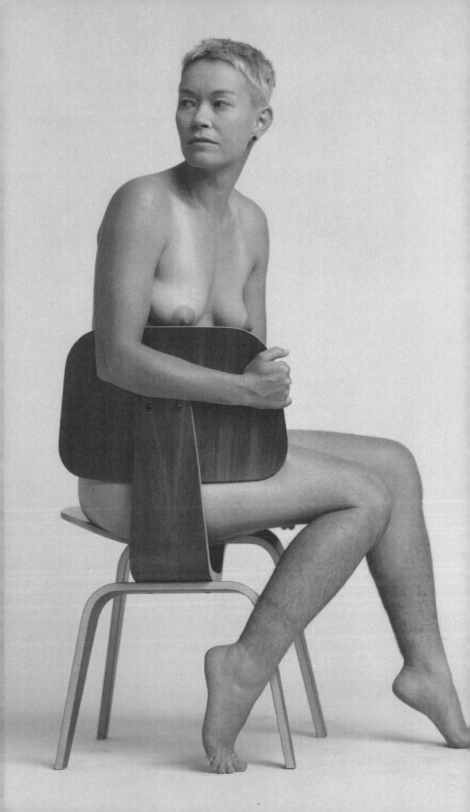

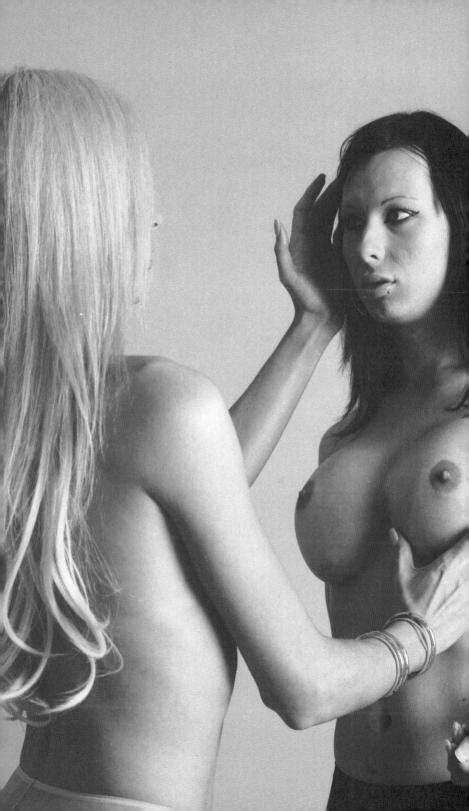

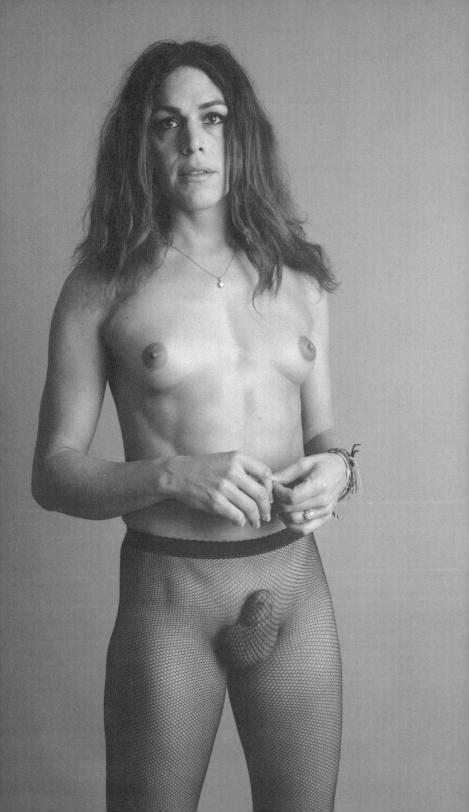

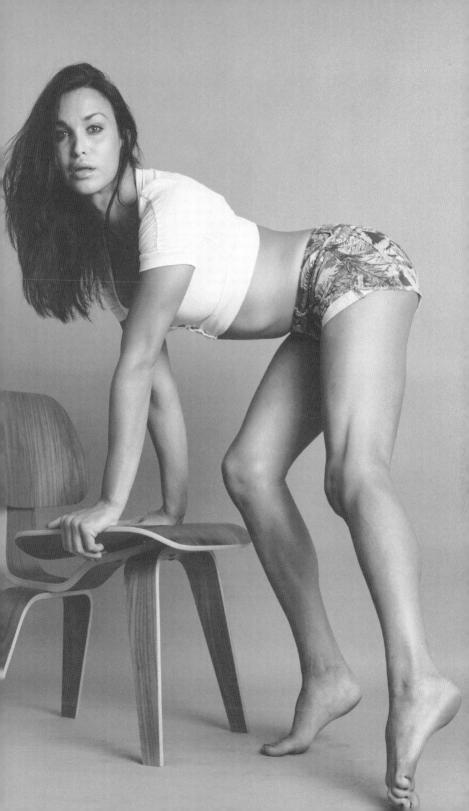

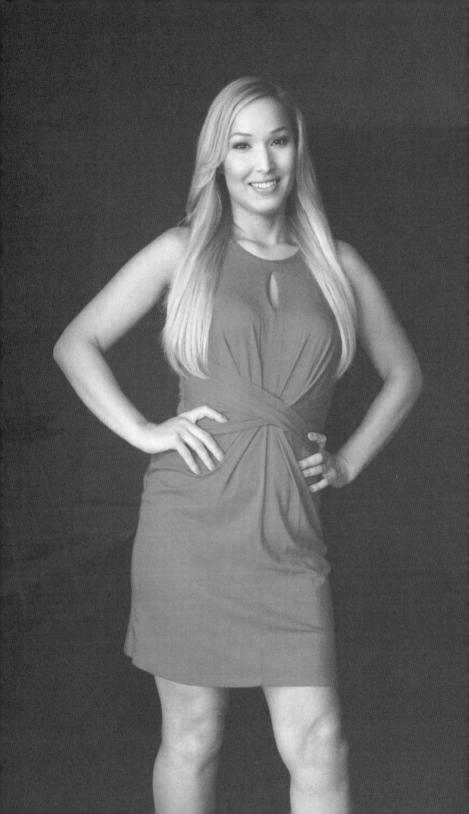

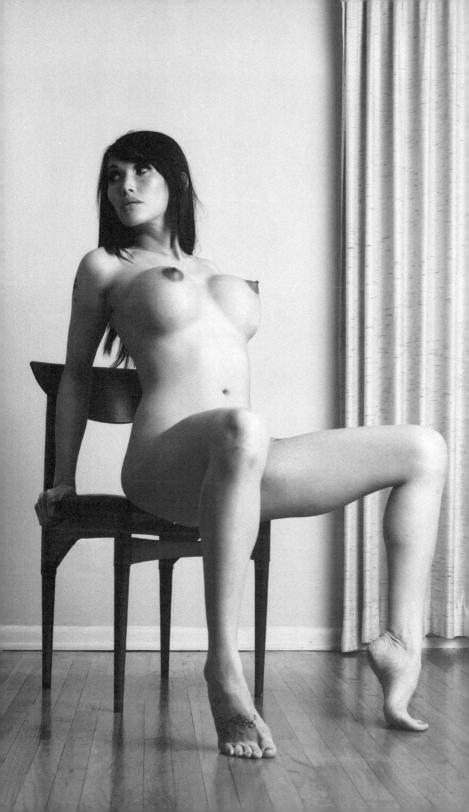

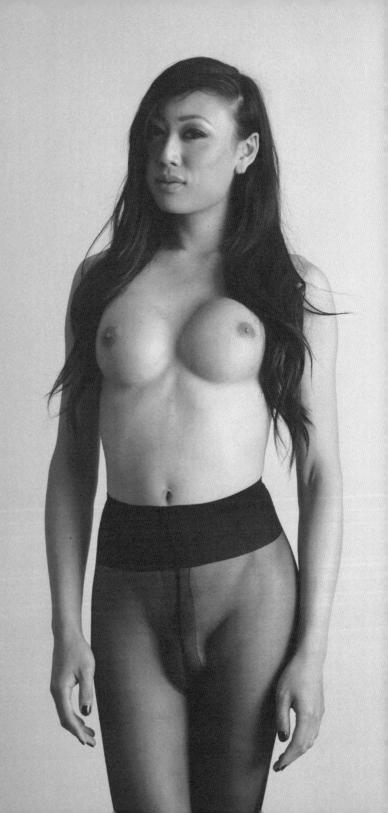

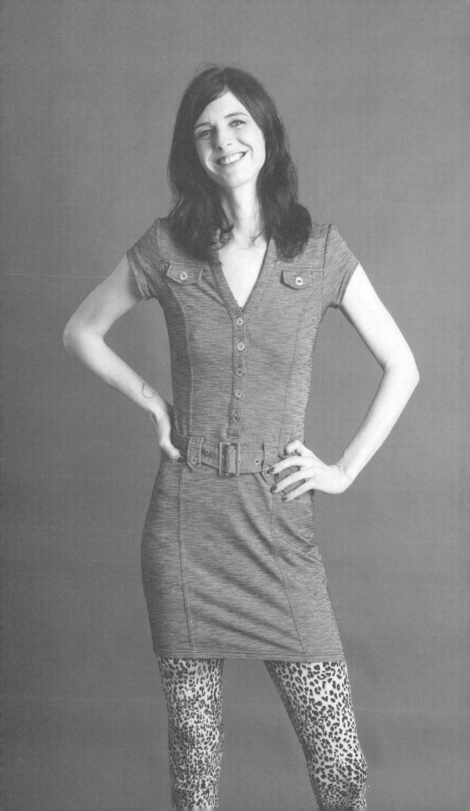

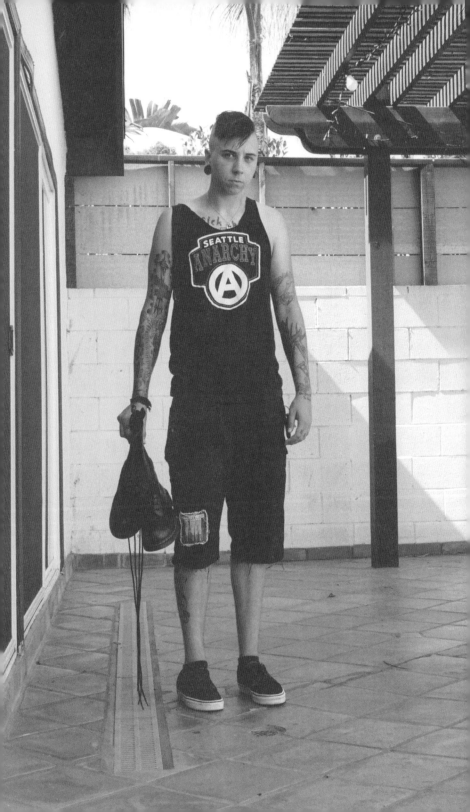

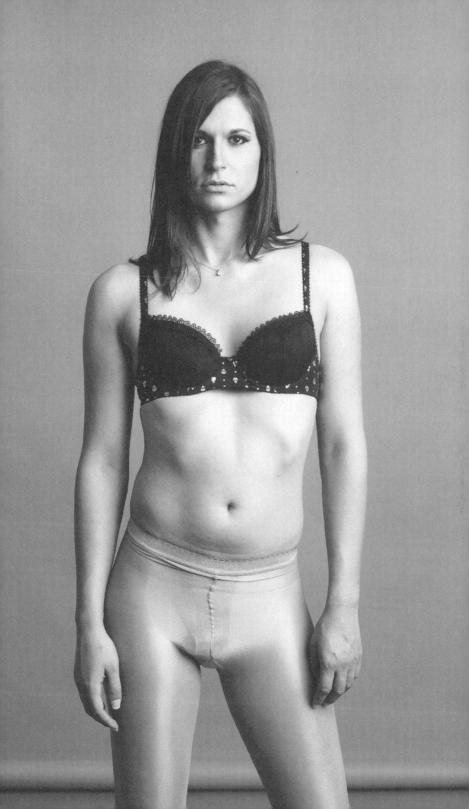

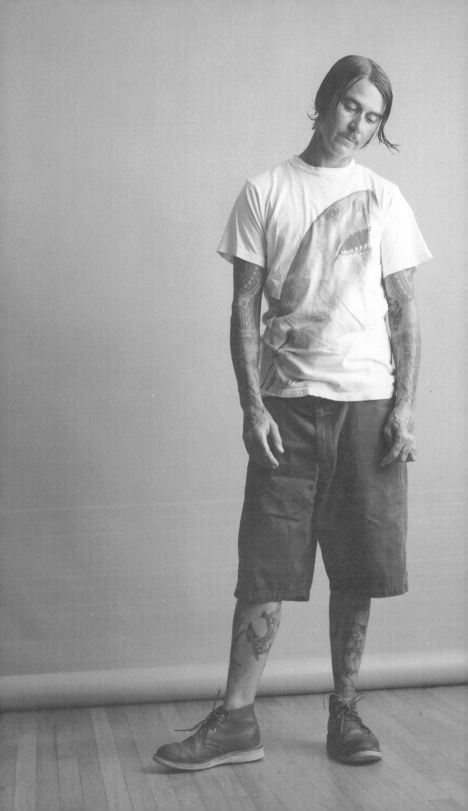

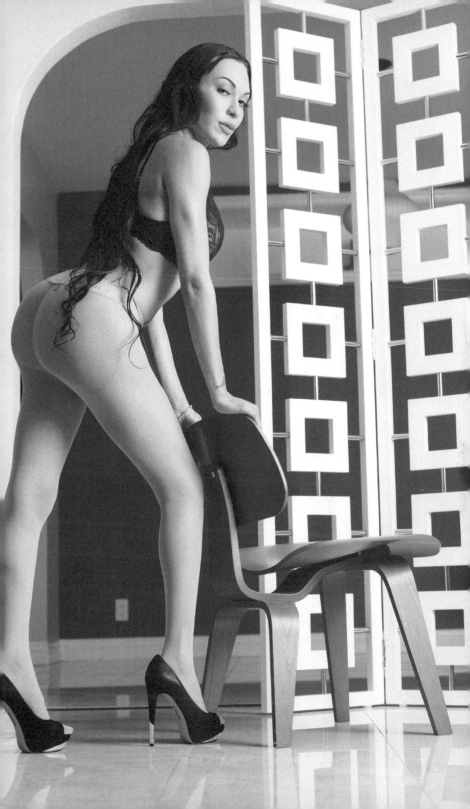

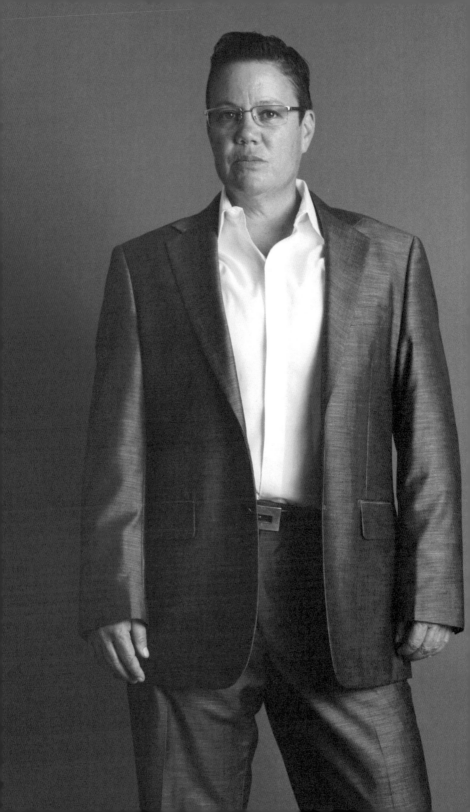

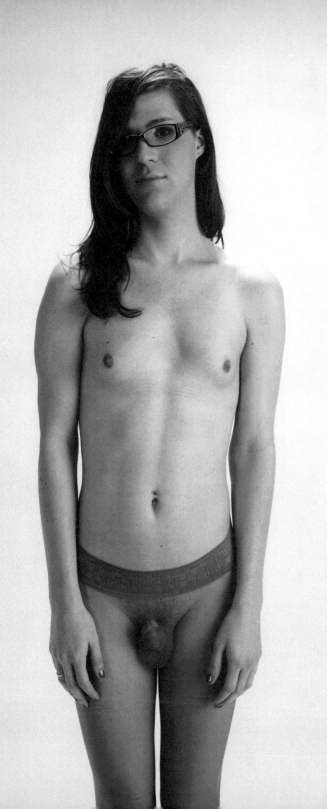

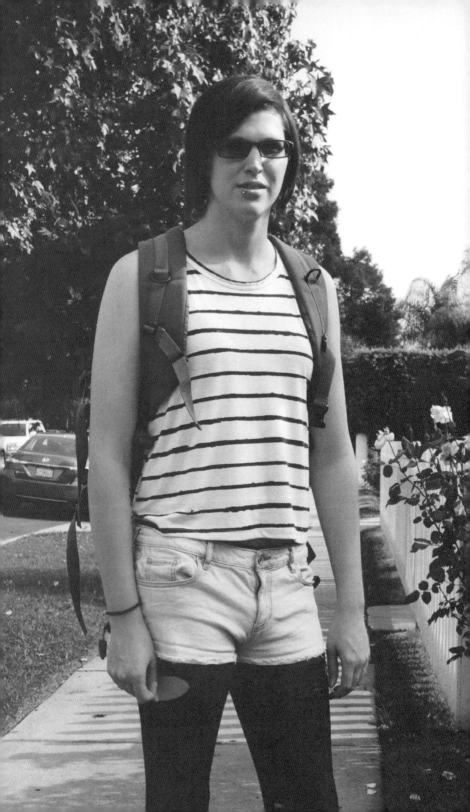

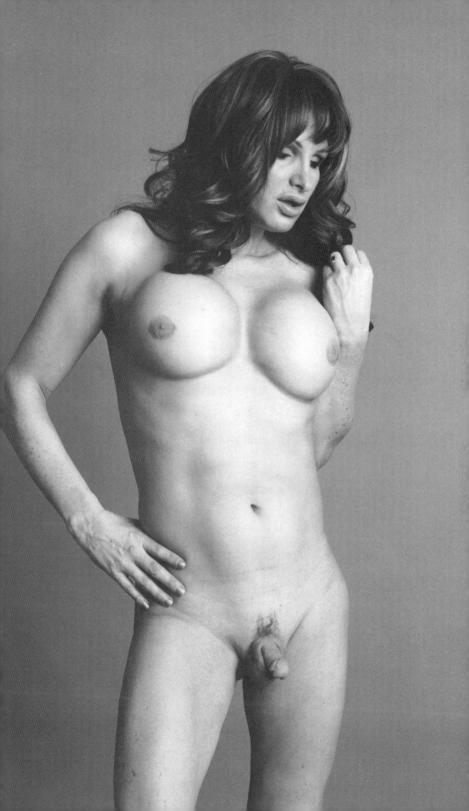

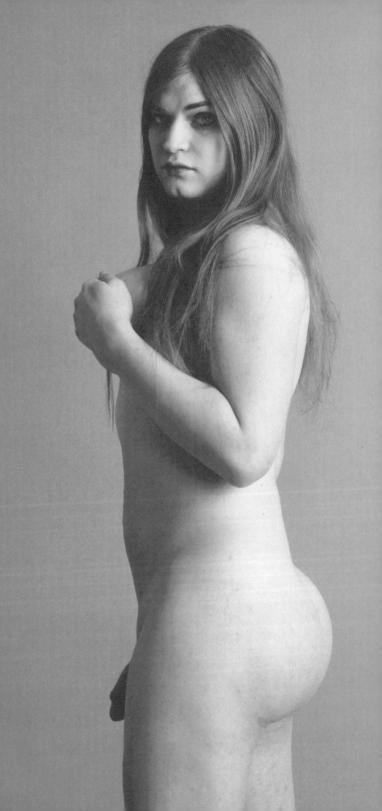

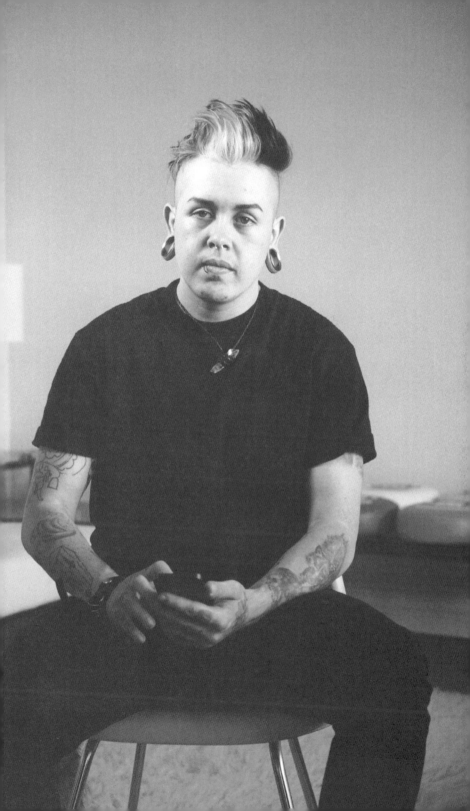

Models:
Athena Addams
Aimee
Buck Angel
Michelle Austin
Morgan Bailey
Adrian Bear
Becca Benz
Birdmountain
Matti Boi
Jonelle Brooks
Brande Bytheway
Eva Cassini
Billy Castro
Chandra
Danni Daniels
James Darling
Drew DeVeaux
Afro Disiac
Orlan Doe
Princess Donna Dolore
Jade Downing
Evie Eliot
Janelle Fennec
Michelle Firestone
TS Foxxy
Jamie French
Myriam Gurba
Milcah Halili

Khloe Hart
Nikki Hearts
Mia Isabella
Jenny
Tara Jolie
Tasha Jones
Riley Kilo
Kwesi
Jiz Lee
Eva Lin
Kelli Lox
Venus Lux
Mandy Mitchell
Wolfe Moon
Cyd Nova
Makayla Pedroza
Pig Pen
Kristel Penn
Chelsea Poe
Nica Ross
Sawyer
Andre Shakti
Shawn
Kendra Sinclair
Stefani Special
Jane Starr
Tiffany Starr
Bianca Stone
Wendy Summers

THIS IS A GENUINE BARNACLE BOOK

A Barnacle Book | Rare Bird Books
453 South Spring Street, Suite 302
Los Angeles, CA 90013
rarebirdbooks.com

Set in Cochin
Printed in the United States

Book design by STARLING

10 9 8 7 6 5 4 3 2 1

Publisher's Cataloging-in-Publication data
Names: Naz, Dave, author.
Title: Identity : in & beyond the binary / Dave Naz.
Description: First Trade Paperback Original Edition | A Genuine Rare Bird Book | New York, NY; Los Angeles, CA: Rare Bird Books, 2017.
Identifiers: ISBN 9781945572517
Subjects: LCSH Transgender people—Pictorial works. | Transgender people—Portraits. | Photography, Artistic. | Transgenderism. | Sexual minorities. | Gender identity. | BISAC SOCIAL SCIENCE / LGBT Studies / General | SOCIAL SCIENCE / Gender Studies | PHOTOGRAPHY / Lifestyles
Classification: LCC HQ77.9 .N395 2017 | DDC 306.76—dc23